*Images of Modern America*

# ROCK CITY

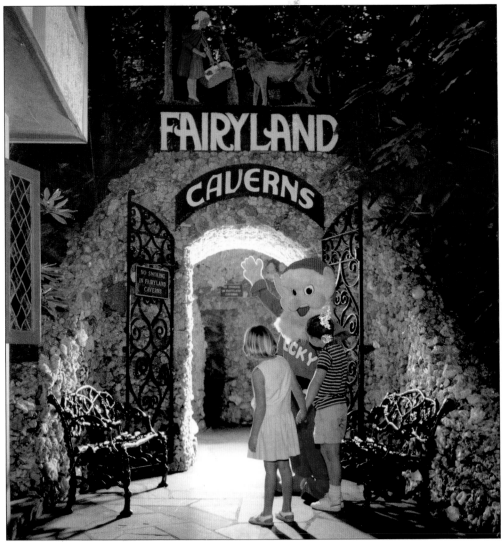

Rocky the Elf, mascot of Rock City Gardens since the late 1950s, stands ready to welcome everyone into his home. Whether still young or only remembering when they used to be, visitors get ready for an amazing journey. (Rock City Archive.)

FRONT COVER: The Swing-A-Long Bridge has been part of Rock City since opening day, and provides an incredible view of the scenery east of Lookout Mountain, seemingly stretching into infinity. (Author's collection.)

UPPER BACK COVER: Lover's Leap, with its legendary view of seven states at once, is arguably the most famous sight in Rock City Gardens. (Rock City Archive.)

LOWER BACK COVER (from left to right): Many major US highways intersected in Chattanooga, ensuring that Rock City and its advertising would be encountered by millions of travelers each year; capitalizing on the postwar baby boom, Fairyland Caverns was added to the end of the Rock City tour in 1947; since the early 1800s, the giant rock formations atop Lookout Mountain had been known to explorers, who referred to the area as "the rock city." (All, author's collection.)

*Images of Modern America*

# ROCK CITY

TIM HOLLIS

ARCADIA
PUBLISHING

Copyright © 2017 by Tim Hollis
ISBN 978-1-4671-2610-6

Published by Arcadia Publishing
Charleston, South Carolina

Printed in the United States of America

Library of Congress Control Number: 2016959101

For all general information, please contact Arcadia Publishing:
Telephone 843-853-2070
Fax 843-853-0044
E-mail sales@arcadiapublishing.com
For customer service and orders:
Toll-Free 1-888-313-2665

Visit us on the Internet at www.arcadiapublishing.com

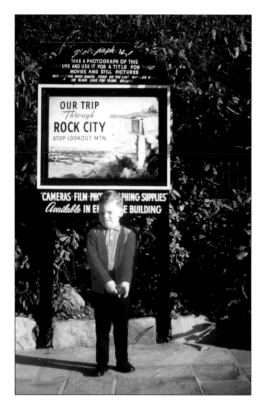

Yes, that is author Tim Hollis on his first visit to Rock City in October 1967. The signboard was conveniently positioned to serve as a title card for tourists' all-important home movies and slide shows. There were even markers painted on the flagstone pavement to show photographers exactly where to stand for the best focus. (Author's collection.)

# CONTENTS

# ACKNOWLEDGMENTS

Most of the information in this book was gathered while working on the earlier history, *See Rock City: The Story of Rock City Gardens* (History Press, 2009). As detailed in its introduction, that book had quite a lengthy genesis stretching back to 1991, when the first interviews were conducted that would eventually be incorporated into it. Therefore, it is appropriate to again credit those sources here, even the ones who are no longer with us. This group of Rock City veterans includes Karen Baker, Kristen Behm, Dick Borden, Clark Byers, Bill Chapin, Ed Chapin, Matthew Dutton, Deb Ellis, Melissa Griggs, Peg Lamb, Martha Bell Miller, Catherine Myers, Kenney Saylor, Jessie Sanders Schmid, and Todd Smith. In addition, much information was gleaned from the countless brochures, postcards, and other promotional material generated by the hyperactive Rock City marketing department over the years.

Unless otherwise credited, all images come from the author's collection.

# INTRODUCTION

Back in 2009, the fine folks at History Press and I teamed up to present *See Rock City: The Story of Rock City Gardens*. As the title hints, it is the comprehensive history of the famed Lookout Mountain attraction, tracing its origins back to the 1820s. This book is not intended to rehash that history; instead, here we take a virtual tour of Rock City via the many colorful photographs, postcards, and promotional items it has produced over the past 75-plus years. However, it is still important to put things into historical perspective, so now it is time to indulge in a bit of that. Those who want the complete history are still encouraged to look up the earlier volume.

Although its environs had been known to pioneers as "the rock city" since the early 19th century, the story of Rock City Gardens' development as a tourist attraction begins around 100 years later, when the property was purchased by Chattanooga promoter Garnet Carter. He had already tried a number of other business ventures when, inspired by the land boom then exploding in the swamplands of Florida, he got the idea of developing a swanky residential neighborhood on the eastern brow of Lookout Mountain. Carter's wife, Frieda, was an enthusiastic devotee of the classic European fairy tales, and it was probably due to this interest that the new development would be known as Fairyland. Statues of the famous folklore folk were imported to decorate the grounds, and Carter's Fairyland Inn was conceived as a resort hotel that would offer many unique facilities for its wealthy visitors.

One of those attractions soon took on a life of its own. On the grounds of the hotel, Carter developed a sort of putting green that challenged its players to manipulate their golf balls around and through various obstacles placed on the fairways, with statues of gnomes and elves stationed throughout. Seemingly without the intention to do so, Carter had invented the game of miniature golf. He soon patented his concept under the name Tom Thumb Golf and began franchising it throughout the United States. When the Great Depression hit in 1929, Tom Thumb Golf (and scores of unauthorized copies of it) became a raging fad, due to its affordability as cheap entertainment; in fact, it was one of the precious few businesses to be making a profit during that dark economic era.

Carter was smart enough to recognize that a fad had only a limited shelf life, so he sold Tom Thumb Golf to the H.J. Heinz Company in 1930, pocketing a tidy sum. Unfortunately, Carter invested his profits in US Steel, which quickly failed and left him worse off than he had been before his Fairyland project got under way. With no other business prospects in view, he began paying more attention to Frieda's project of developing their nearby acreage into a garden, with pinestraw-covered trails winding around the many huge rock formations and leading to the promontory known as Lover's Leap, from which it was said one could see into parts of five states at once.

Carter felt that Frieda's oversized rock garden—with oversized rocks to match—might have real business possibilities. And, as he said later, he realized that unlike Tom Thumb Golf, which had been copied over and over again, in Rock City Gardens he had something that could not

be duplicated by the hand of man. After much effort and even more local promotion, Rock City opened to the public on May 21, 1932.

At that point in history, the idea of a roadside tourist attraction was a fairly new one. The era of automobile travel had barely gotten under way when the Depression slammed on the brakes, and Carter realized that if he were going to lure thousands of people to the top of Lookout Mountain, they had to be made aware that something was there to be seen. Just a few years after opening, Carter hired a young sign painter named Clark Byers to begin traveling the highways of the eastern half of the United States, putting Rock City advertisements on barn roofs. Although legend has it that Carter introduced his new advertising campaign by giving Byers a piece of paper with three scribbled words—SEE ROCK CITY—the reality is that the vast majority of barn roofs sported slogans that were more complete than that. Often, they gave the mileage to Lookout Mountain and/or Chattanooga; with all their many messages, the Rock City barns were farmed out as far north as Lansing, Michigan, and at least as far west as Marshall, Texas.

The barn roof advertisements did just as Carter had planned, and when coupled with aggressive promotions that enlisted the help of roadside motels, restaurants, and gas stations to distribute items bearing the Rock City name, the gardens were soon attracting tourists like the rocks attracted moss. After a temporary setback in tourism during World War II, Rock City boomed back during the baby boom, adding Fairyland Caverns to the end of the tour. This was clearly the ultimate manifestation of Frieda Carter's passion for fairy tales, even though by that time she was suffering the effects of multiple sclerosis—or at least an illness closely resembling it—and could no longer see the additions and improvements being made.

Rock City today still very much resembles the way it looked in 1950, an unusual characteristic in the tourism business, where "out with the old" is almost a mantra. Rock City prides itself on its own history. Even though a number of features have been added during the past 20 years or so, they have never been allowed to overshadow the traditional experience of the gardens' Enchanted Trail. This book is arranged in the same order a visitor would come upon its sights when strolling that trail, so now it is time to get started. Just sit back and relax as we begin to SEE ROCK CITY.

# One

# ALONG THE
# ENCHANTED TRAIL

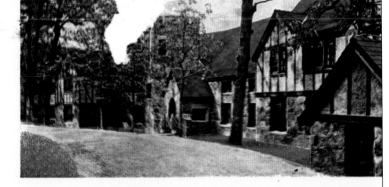

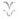
Rock City's story truly begins with the development of a residential neighborhood known as Fairyland and a resort hotel called the Fairyland Inn, during 1924–1925. The streets in the Fairyland community were named for various storybook characters, and statues of those legendary heroes were imported from Germany to decorate the vicinity. (Rock City Archive.)

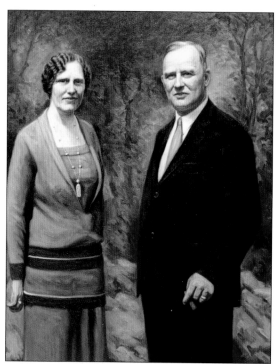

The developers behind Fairyland were Garnet Carter and his wife, Frieda. It was Carter's business acumen and Frieda's love for classic European folklore that combined to give the neighborhood and hotel their charm. (Rock City Archive.)

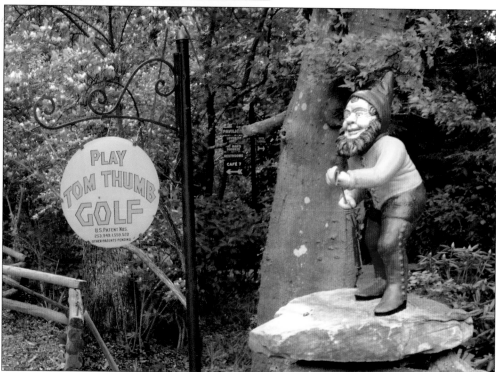

To entertain guests at his Fairyland Inn, Garnet Carter invented a new game he patented as Tom Thumb Golf. It turned out to be the first commercially successful miniature golf course, and Carter had soon made a fortune by franchising his idea nationwide.

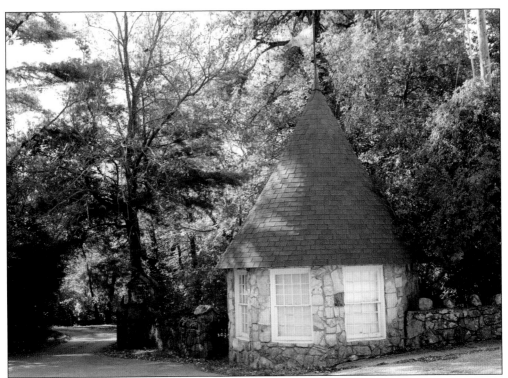

After selling Tom Thumb Golf and then losing most of his profits in the Great Depression, Carter then set out to develop his wife's adjoining rock garden as a tourist attraction. Rock City Gardens had its grand opening on May 21, 1932, with this cone-shaped building as its ticket office and souvenir shop.

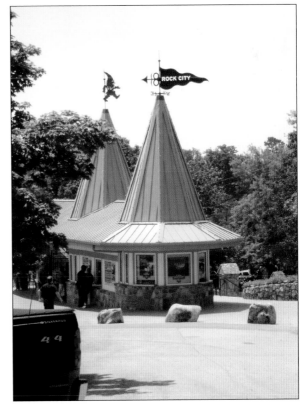

In a noteworthy nod to its origins, when Rock City had new ticket booths constructed some 70 years after its opening, they were patterned after the original 1932 entrance building. Even the metal "banner" with the Rock City name was modeled after the one that can still be seen atop the original entrance.

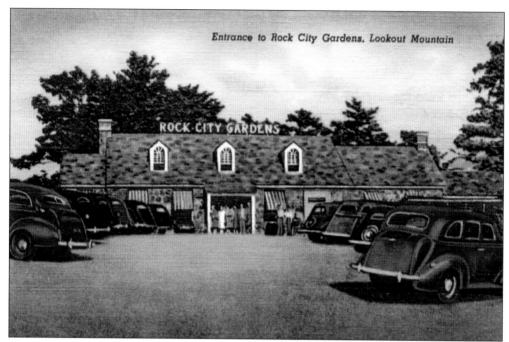

In 1937, a new stone entrance building was constructed to take the place of the original round structure. This enabled visitors to begin their tour at a more picturesque point than the first building, the location of which necessitated a rather lengthy hike to reach the head of the trail.

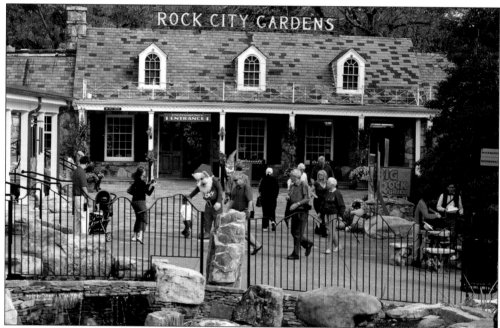

Although cars originally parked in front of the new 1937 entrance building, as seen in the postcard at the top of this page, it was not long before a new parking lot was constructed across the street, leaving the entrance court clear for a gift shop, a restaurant, and other amenities. (Rock City Archive.)

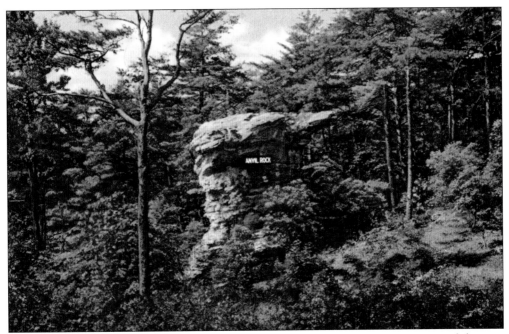

Regrettably, one of the natural features that had to be sacrificed for construction of the new parking lot was the aptly named Anvil Rock. Its loss would hardly be felt due to the many other interesting rock formations throughout the property.

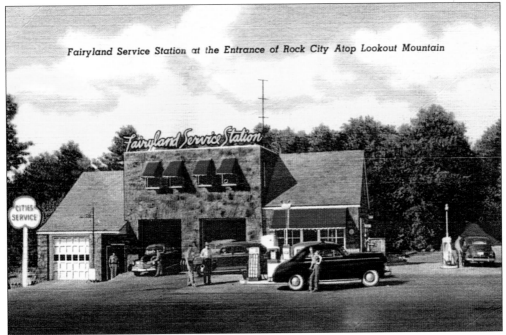

Frieda Carter personally designed the Fairyland Service Station adjoining the new Rock City parking lot. It filled thousands of visitors' cars with gas for many years before being converted into a Starbucks outlet, its current incarnation.

The original Rock City souvenir shop sat just to the left of the entrance building. The position of the home movie title sign pictured on page 4 can also be seen.

Most people probably do not even notice these stone drinking fountains at Rock City's entrance. In the bad old days, the one on the right was for "whites only," while the one on the left was the "colored" fountain. Once that Southern tradition was dead and buried, both were used equally, but one is now a planter and the other is nonfunctioning.

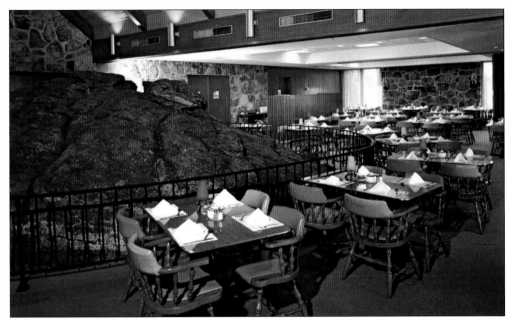

In 1968, a new restaurant was constructed in the entrance court, built around a giant rock formation that sat just to the right of the original, smaller snack bar. Even at that, a portion of the stone monolith had to be blasted away to accommodate the restaurant's foundation, but as one can tell, what was left was certainly impressive enough.

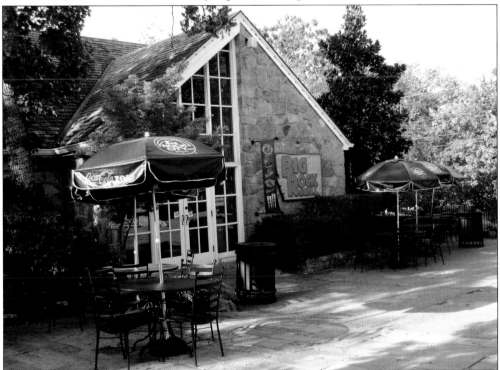

Having undergone several names over the years, the restaurant is currently known as the Big Rock Grill—named, not surprisingly, for its most distinctive interior decoration.

In the 1990s, those waiting in line to buy admission tickets were entertained by a robotic elf named Alvin, who gave a prerecorded spiel concerning the sights to be seen in Rock City. During the busiest part of the tourist season, an employee could operate Alvin manually and carry on conversations with visitors.

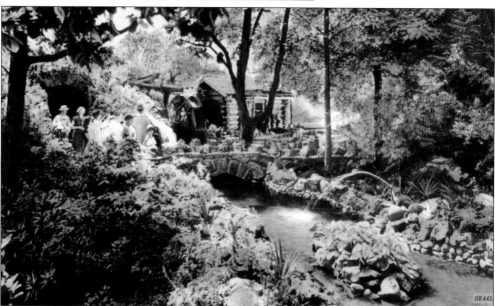

At the beginning of the Enchanted Trail, the first thing guests of the 1950s saw was the water-spouting frog, a decorative piece that dated back to the early 1930s. The artificial amphibian became something of a legend and an anticipated sight for returning tourists.

In 1960, Rock City got a new entrance pool, this one the same unmistakable shade of aqua as a kiddie swimming pool. Not only did the water-spouting frog remain on duty, but he was also joined by a number of his less animated froggy friends.

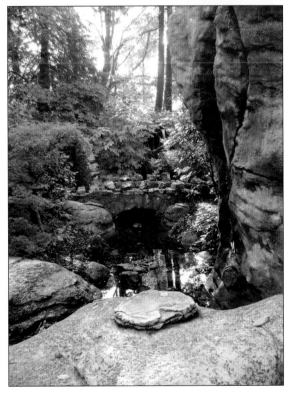

Finally, during a major remodeling of the entrance building in 1992, it was felt that the old aqua-colored plastic pool was a relic of a bygone era. The designers of Chattanooga's Tennessee Aquarium furnished Rock City with a new entrance fountain that more closely fit in with the natural rock formations of the area; the spouting frog was removed from public view but remains preserved in case he should ever be called back into active duty.

ENTRANCE TO ROCK CITY, LOOKOUT MOUNTAIN, CHATTANOOGA

After all the preliminaries, the Rock City tour actually began with the aptly named Grand Corridor. This 1940s linen postcard provides one rendition of the view a person faced after stepping through the doorway to the beginning of the Enchanted Trail.

Because of its natural beauty, the Grand Corridor may be the part of Rock City that has changed the least over the past eight decades. The giant boulders and abundance of flowering plants make an immediate impression, whether one is seeing them for the first or 50th time.

There has been at least one change in the Grand Corridor, although most people might not notice. For many years, the first sight visitors saw, perched on a boulder on the left-hand side, was a statue memorializing Garnet Carter's beloved dog Spot, who was often referred to as "Rock City's mascot." Although Spot no longer watches over the Grand Corridor in model form, it is pleasant to think that his spirit—as well as Carter's—will always watch over Rock City. (Right, Rock City Archive.)

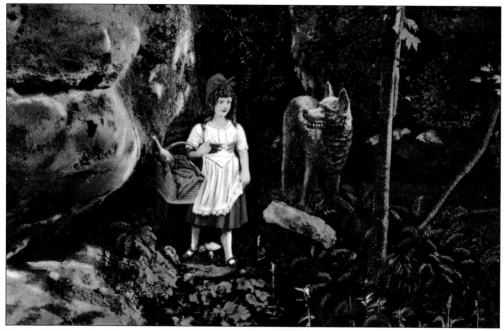

Many of the imported German fairy tale statues that had decorated the Fairyland neighborhood were moved to Rock City in the 1930s and placed in appropriate settings along the Enchanted Trail. Red Riding Hood and the Big Bad Wolf were among the first of this new wave of immigrants.

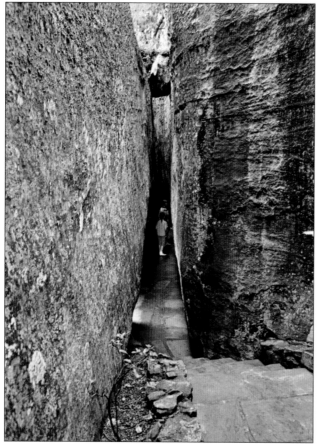

At the end of the Grand Corridor, the formidable-looking Needle's Eye was sure to give pause to those with encroaching middle-age spread. But never fear—it remains easier to navigate than it first appears, and few people have trouble threading themselves through it.

Rock City's Deer Park was home to a herd of white fallow deer that took up residence there in 1939. By the 2000s, it became obvious that the rock-and-concrete pit was not the most natural habitat for the animals, so they were moved to a more hospitable area along the trail. In this 1967 photograph, readers can also spot the deer's companion, Charlie the llama, who dwelled peacefully with them for some 15 years.

After the deer were relocated, their former home was converted into Gnome Valley. From the beginning, Rock City had depicted life among the bearded elves at various points along the trail, and this was something of a return to that tradition after many years.

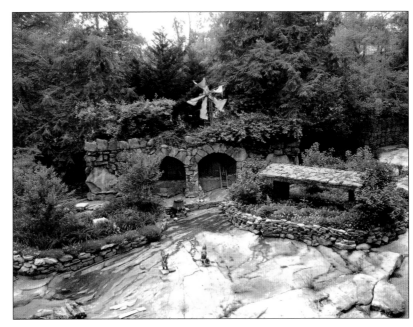

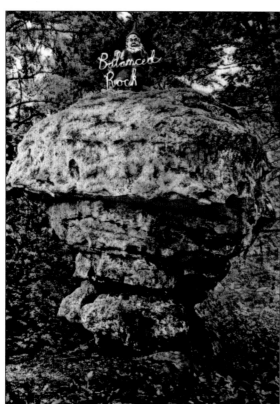

After the Deer Park, the next sight was a top-heavy boulder that, as seen in this 1930s postcard, was originally known as Balanced Rock. That was just fine, but when a larger, more impressive Balanced Rock was discovered later in the decade (see page 43), this one needed a new name.

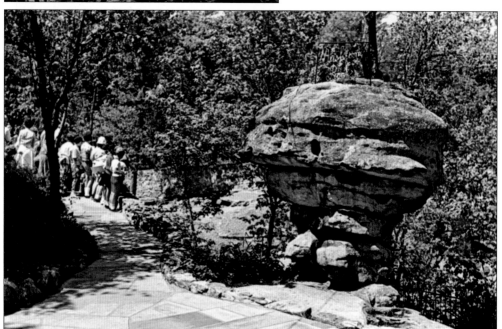

The former Balanced Rock became known as Mushroom Rock, which is pretty much what it more closely resembled all along. It retains that name today, as yet another of nature's creations to be enjoyed along the Enchanted Trail.

Man-made creations can also be found augmenting those of nature at Rock City. One of the more recently commissioned works of art is *Villa Aviana* (House of Birds), an aluminum sculpture by artist Jack Denton. It represents one of the famous Rock City birdhouses—more about those on pages 81–83—as it might look if built by birds using native plants. The huge piece was installed in 2012 to commemorate Rock City's 80th anniversary.

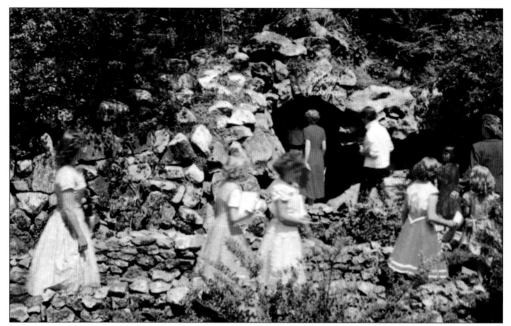

The next challenge to be navigated is the slightly eerie Goblins' Underpass, taking visitors on a brief underground journey. On the day this 1950s postcard view was taken, it would appear all of those visitors were wearing their Sunday-go-to-meeting clothes.

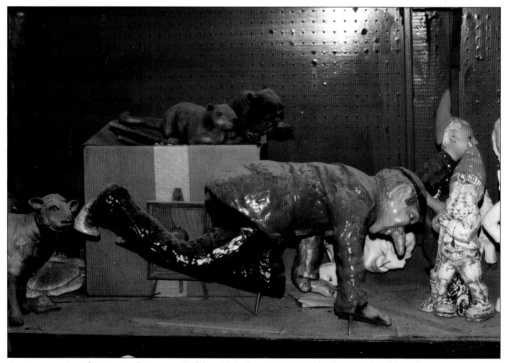

At some point during its history, Goblins' Underpass actually featured goblins leering at guests through openings in the ceiling. The goblins were vanquished long ago, but in 1991, this one could still be found lurking in Rock City's art studio.

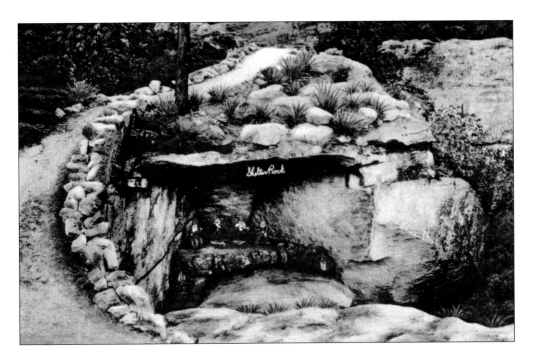

Shelter Rock underwent a rather drastic metamorphosis during Rock City's early years. As seen above, it originally had no floor, so was merely a place to observe a gnome orchestra playing silent instruments. By the time of the postcard below—in which the tourists are again decked out in their Sunday best—the floor had been filled in and the cove made into a resting spot. What became of the gnome orchestra? Readers encounter them again a few pages hence.

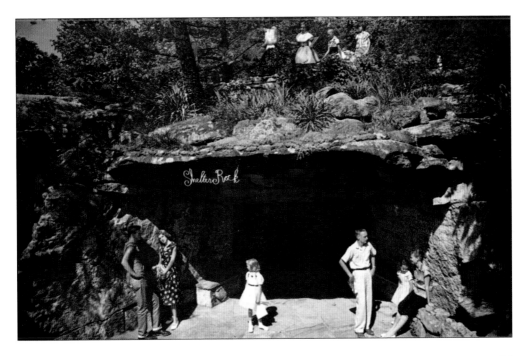

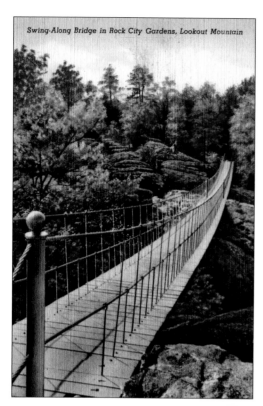

Swing-Along Bridge in Rock City Gardens, Lookout Mountain

The original Swing-A-Long Bridge was built in 1932 using discarded cables from the Lookout Mountain Incline. Postcards such as this one are colorized versions of black-and-white photographs; unfailingly, the painters were instructed to make the foliage look like autumn, regardless of when the original photograph was actually taken.

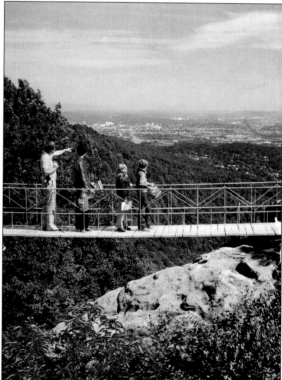

The Swing-A-Long Bridge still gives a breathtaking view of the valley just east of Lookout Mountain. It serves as a fitting approach to the most famous spot in Rock City: Lover's Leap. Not surprisingly, readers spend some time there in the next chapter.

# Two

# LOVER'S LEAP

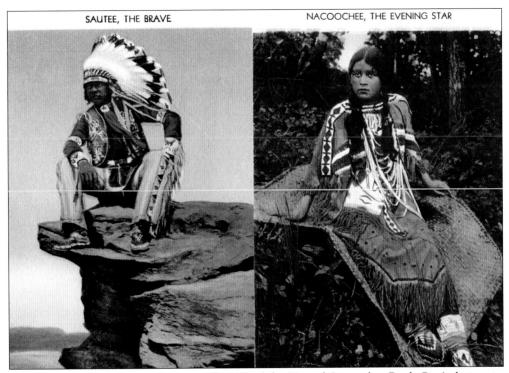

SAUTEE, THE BRAVE      NACOOCHEE, THE EVENING STAR

Of course, there are Lover's Leaps in all parts of the United States, but Rock City's derives its reputation from the legend of these two. Nacoochee's father objected to her romance with Sautee, and when he thought he was solving the problem by throwing Sautee off the precipice of Lookout Mountain, Nacoochee took matters into her own hands and leaped after her sweetheart. It would appear this 1930s postcard company used images of Plains Indians, rather than the Cherokee, to depict the unlucky pair.

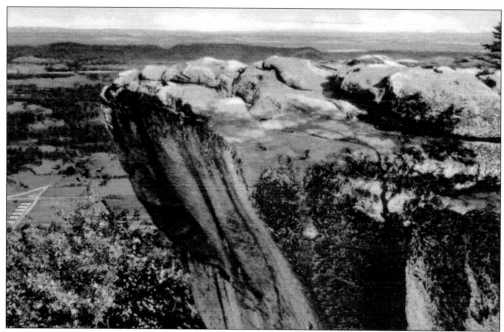

Amazingly, from a modern-day point of view, when Rock City first opened to the public, Lover's Leap was left in its natural state. No walls existed to keep tourists from inadvertently reenacting the fate of Sautee and Nacoochee, and the walking surface was hardly smooth or level. Tourism moguls of today consider scenes such as this an insurance company's nightmare.

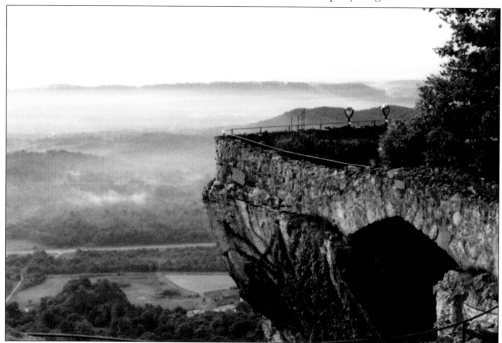

By the late 1930s, Lover's Leap had "been made safe for the public," as the caption on one postcard phrased it. It has remained largely unchanged since then, and the view is still enough to make one gasp.

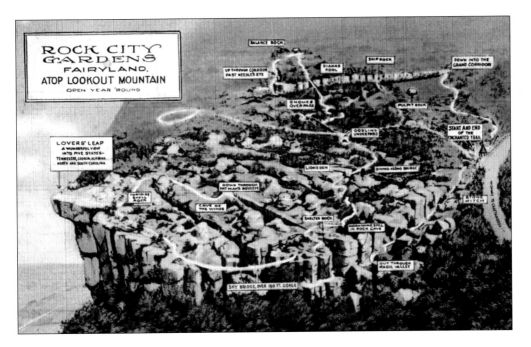

As seen in the mid-1930s postcard above, originally the idea was that one could see five states from Lover's Leap: Georgia, Alabama, Tennessee, North Carolina, and South Carolina. But since well before the Civil War, it had been said that seven states could be seen (Kentucky and Virginia being the more distant ones). Before long, Rock City adopted the "See Seven States" slogan it would use from then on.

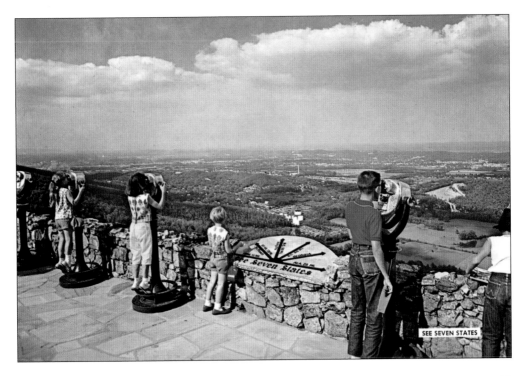

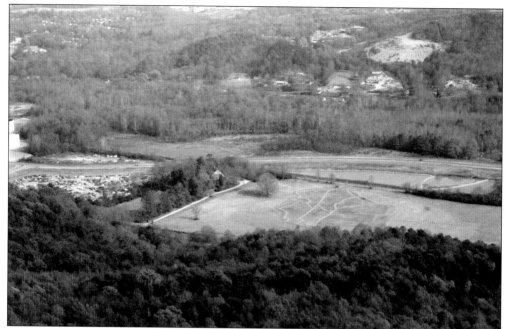

In 1977, Rock City purchased Blowing Springs Farm and its Civil War–era farmhouse in the valley far below, mainly to ensure the view from Lover's Leap would never be compromised. At the time of this 1991 photograph, the farm was planted with the outlines of the seven states—possibly as a joke to satisfy those who questioned the claim.

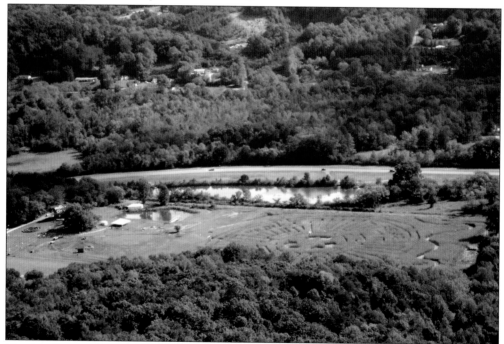

Blowing Springs Farm is currently the site of many additional Rock City activities, including the annual Halloween celebration and the Enchanted Maize. It is still the most immediate view from Lover's Leap.

Because Lover's Leap faces due east, the sunrise is an incredible sight as the glowing orb slowly makes its daily appearance over the distant mountains. Due to the privacy of the spot, few people get to enjoy a daybreak experience there, although for several years it was made available for Easter sunrise services.

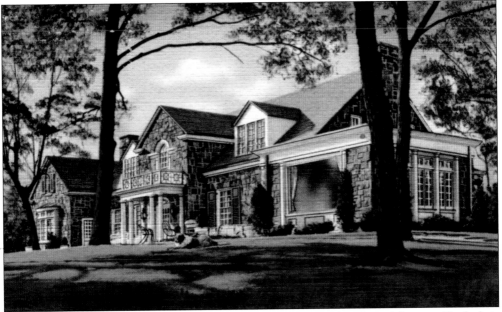

Garnet and Frieda Carter recognized the uniqueness of the view from Lover's Leap and built their own home, Carter Cliffs, on the adjoining bluff. The beautiful residence has served as a sort of "president's mansion" for Rock City since the late 1930s.

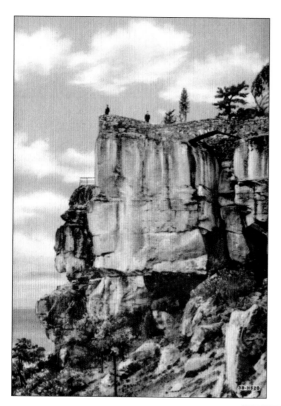

Rock City never made any secret of the fact that its High Falls at Lover's Leap was strictly man-made, one of the first additions made after World War II. This mid-1940s postcard shows how the spot looked before construction of the falls began.

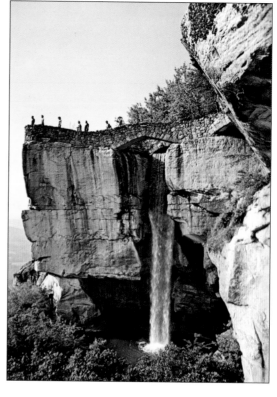

The addition of High Falls in 1946 was the finishing touch to make Lover's Leap into today's familiar sight. It is said that occasionally people having dinner at the nearby Fairyland Inn would be surprised to see the magnificent waterfall suddenly shut off at sundown.

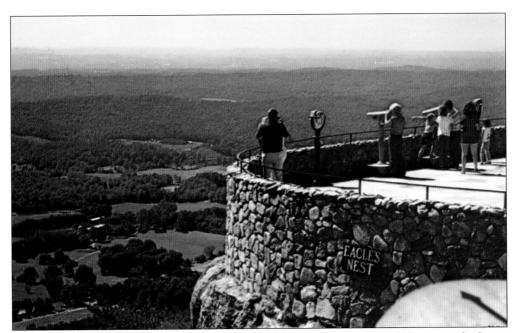

The Eagle's Nest has long been an adjunct to Lover's Leap. During the 1960s, it was the home of the Camera Obscura, a small building where a reflection of the panorama below Lover's Leap could be viewed on a large glass table. It turned out most people were more interested in looking at the view itself, rather than just a reflection of it.

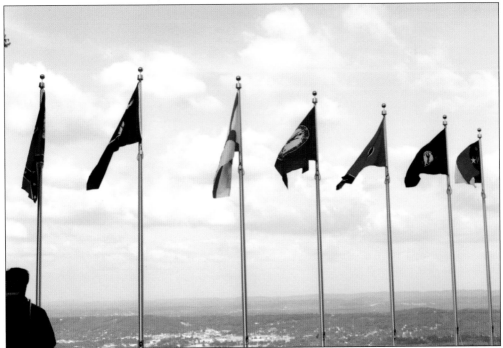

In time for Rock City's 60th anniversary in 1992, the Eagle's Nest observation deck was converted to the Seven States Pavilion, with the flags of each proudly blowing in the almost constant breeze of that altitude.

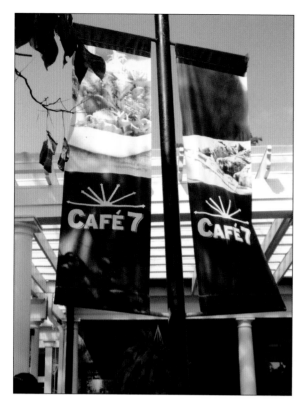

Another reference to the seven states visible from Lover's Leap is Café 7, where guests can fortify themselves with a snack or meal before plunging into the second half of the winding Enchanted Trail.

Simulated gem mining attractions have been featured at many tourist spots in recent years, and Prospector's Point at Lover's Leap enables every youngster to become a junior Gabby Hayes—beard and floppy hat optional.

# *Three*

# OUT THROUGH
# MAGIC VALLEY

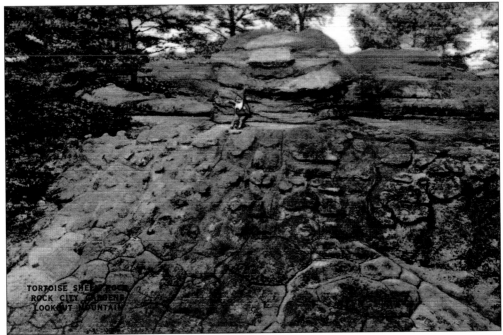

The second half of the Enchanted Trail begins with the aptly named Tortoise Shell Rock. More than one person has observed that in addition to the eponymous pattern, the top portion of the formation resembles the face of a jolly clown.

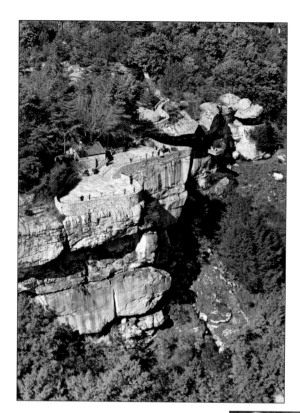

This incredible aerial view of Lover's Leap and its adjoining sites is certainly one that most visitors never get to see. It first appeared in one of Rock City's souvenir booklets in the 1980s.

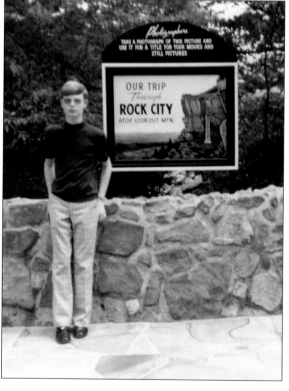

Back on page 4, the author is seen posing with this sign when he was four years old. Here he is as a high schooler in 1978; the sign was the same but had been moved from the entrance court to the area just after Lover's Leap, which somewhat negated its original use as a home movie title card.

At some point, parts of the Enchanted Trail after Lover's Leap were rerouted. This 1940s postcard, labeled simply "Rock resembling a prehistoric animal," was photographed from an angle that is no longer accessible to the public. The formation is still there but unidentifiable from the current trail.

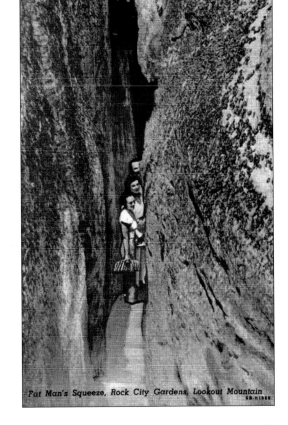

Fat Man's Squeeze, Rock City Gardens, Lookout Mountain

Those who were relieved at making it through the Needle's Eye during the early part of the tour could be excused for groaning a bit when faced with Fat Man's Squeeze in the second half of the trail. As with the Needle's Eye, it looks more intimidating than it really is.

37

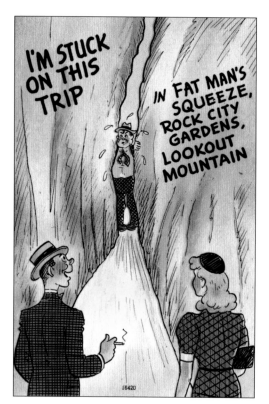

Although Fat Man's Squeeze was always good for a gag, such as this 1940s cartoon postcard, Rock City proudly reports that no guest has ever become permanently wedged in its corridor.

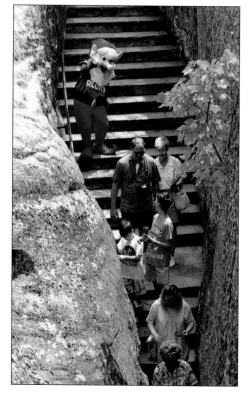

These people are descending the long flight of steps that lead into Fat Man's Squeeze. Rocky the Elf seems to be waving them a fond farewell—hopefully not a final one. The costumed Rocky became a mainstay of Rock City during the 1980s, and eventually the Rocky artwork used in advertisements was even redrawn to more closely resemble the outfit.

For many years, this lantern-wielding gnome has been a welcome sign that Fat Man's Squeeze is past. At one time, similar gnomes could be found in many places along the trail, but most have now been retired to indoor quarters to preserve them from weather and other possible damage.

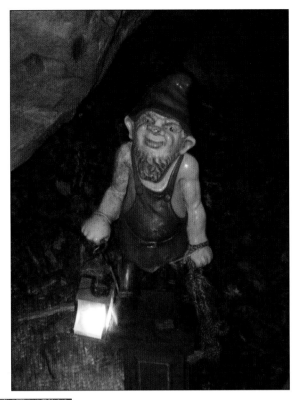

The latest addition to Rock City's works of original art is *Maloria, Mother of the Wild*, a mythical figure sculpted by former Fairyland Caverns caretaker Matthew Dutton. The wood nymph (who is actually not made of wood but a combination of steel, foam, fiberglass, and copper) was installed in the summer of 2016 on a rock beneath the Swing-A-Long Bridge.

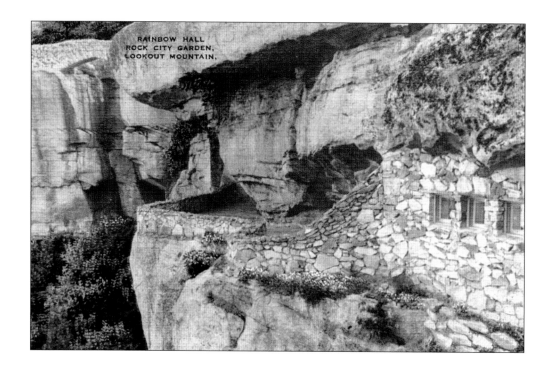

Rainbow Hall, set into a passageway that was blasted through solid rock, was the type of site that really served no purpose except to be pretty. Different colored panes in the windows allowed everyone to see the valley below through rose-colored (or green or yellow or blue) glasses.

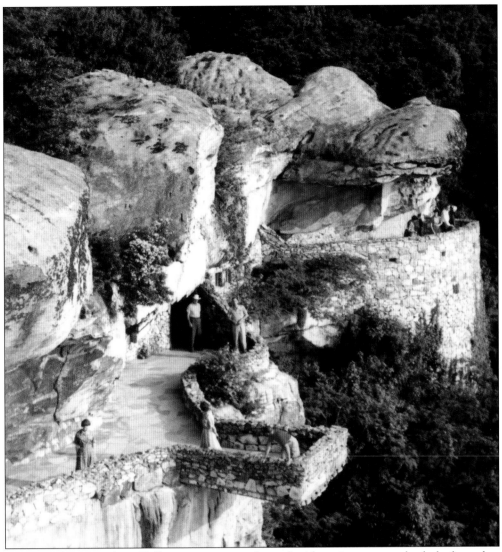

Emerging from Rainbow Hall, guests were confronted with a giant stone-edged platform that seemingly extended into space over the trees far below. This section of Rock City was labeled as Undercliff Terrace in the guidebooks, and a fitting name that was.

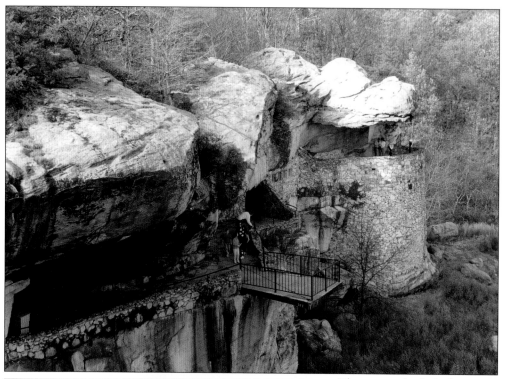

The stone-edged platform has since been replaced by a more lightweight model, but it still gives a feeling of weightlessness as it suspends visitors over the valley.

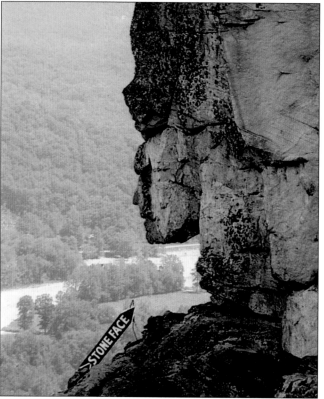

Undercliff Terrace and its environs provide a good view of Rock City's Stone Face, a profile that juts out from just below Lover's Leap. It bears a remarkable similarity to the larger and more famous Great Stone Face of New Hampshire, which unfortunately crumbled off its mountain in 2003.

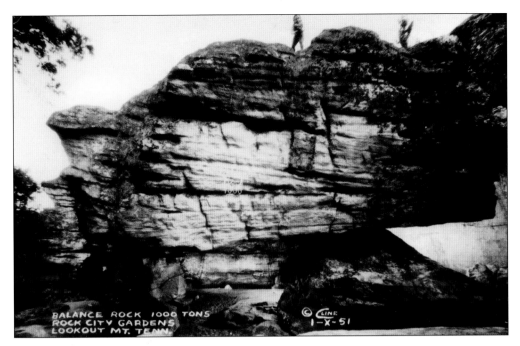

On page 22, Rock City's original Balanced Rock that was eventually renamed Mushroom Rock is seen. That change took place because in the mid-1930s, workers in the gardens excavated this much larger example that became known as the 1,000-Ton Balanced Rock. Comparing the photograph postcard above with the colorized linen version below shows how thoroughly the artists could change not only the colors of an object, but also its entire surroundings, making it look like the rock is sitting in the middle of a desert.

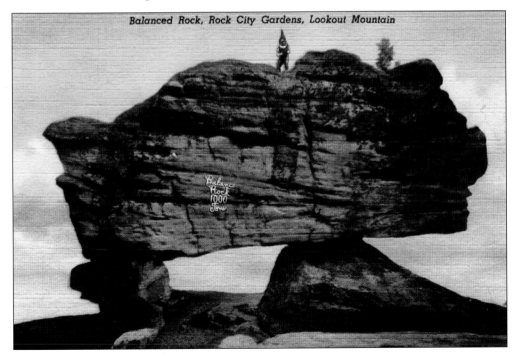

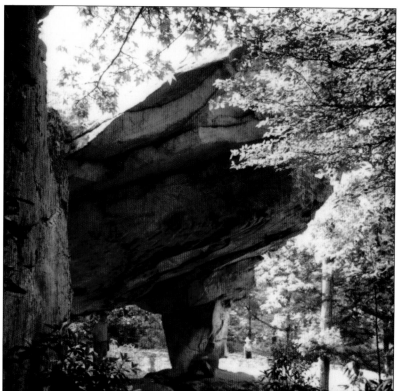

This is the most familiar angle for viewing the 1,000-Ton Balanced Rock. Once the earth had been moved from around its bulk, no one was certain it was balanced permanently, so Garnet Carter forbade anyone from approaching it until it had sat untouched for a year.

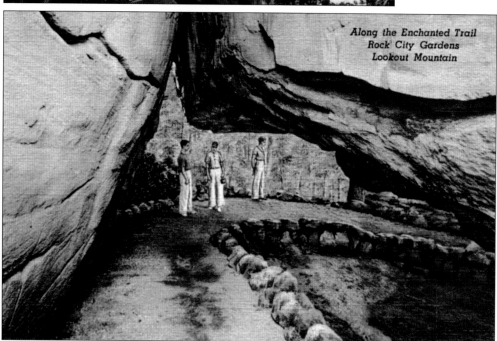

*Along the Enchanted Trail*
*Rock City Gardens*
*Lookout Mountain*

Next on the tour is the Hall of the Mountain King. Early explorers of Lookout Mountain made reference to it as a place where evidence of ancient Native American habitation could be seen; the rocks overhead still bear the soot marks from centuries-past campfires.

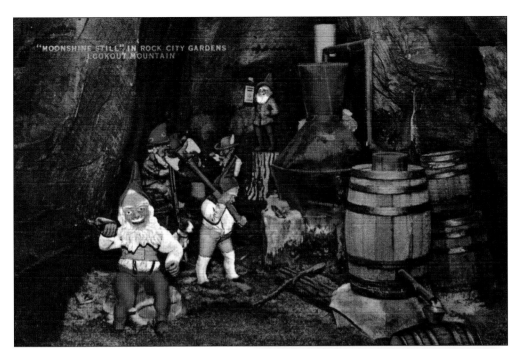

The Moonshine Still diorama, with its crowds of alcoholic gnomes, was installed in 1933 and some version or another of it has been visible ever since. Legend has it that the remains of an actual still were found in that particular cavern, although it may or may not have been operated by elves.

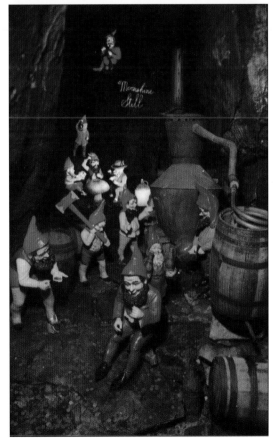

Its cast of characters has grown, dwindled, and then grown again over its 80-plus years, but the Moonshine Still scene was never more colorful than in this 1950s postcard view. Many people probably missed noticing the card game going on in the background, with a mushroom for a table.

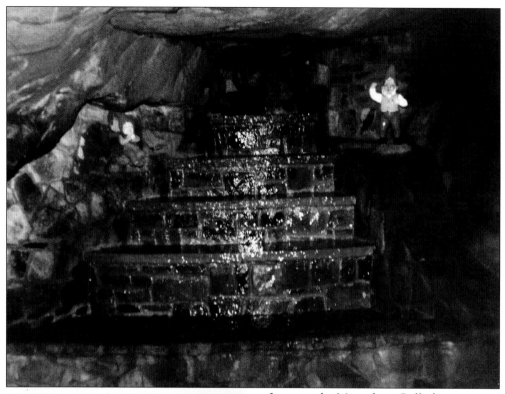

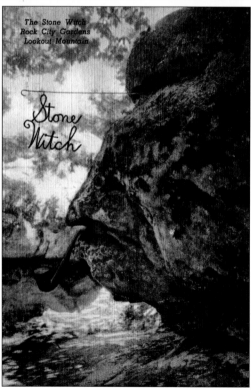

The Stone Witch
Rock City Gardens
Lookout Mountain

Stone
Witch

Just past the Moonshine Still, this fountain may be found. But is that really water, or could this be the outlet for the mountain dew the mischievous gnomes are brewing nearby?

When the last portion of the Rock City trail was altered in the late 1940s, the Stone Witch was one of the sights not included in the new route. In recent years, a seasonal branch off the main trail has been added so visitors can once again visit the pipe-smoking old crone.

# *Four*

# FAIRYLAND CAVERNS

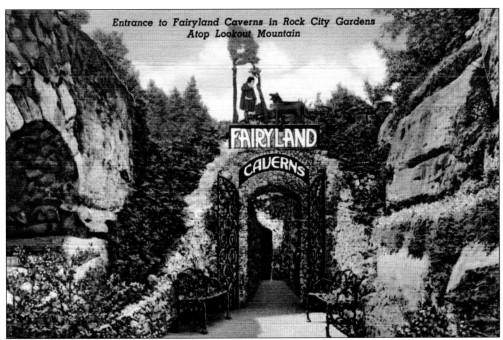

What caused the rerouting of the end of the Enchanted Trail was the construction of Fairyland Caverns. In this early view of the entrance, notice the tunnellike opening on the left side. This is the remnant of an aborted project to construct a miniature railroad that would take guests back to the entrance building.

Originally, the entrance room to Fairyland Caverns contained an information desk where film and souvenirs were also sold. Looking closely at this rather stiffly staged shot, one can see the staffer on the inside displaying a 1950s Rock City souvenir book.

Because of the human traffic jam it created, the souvenir stand was eventually moved to a chalet-styled structure that sat in front of the abandoned railroad tunnel. This cleared a less encumbered path into Fairyland Caverns.

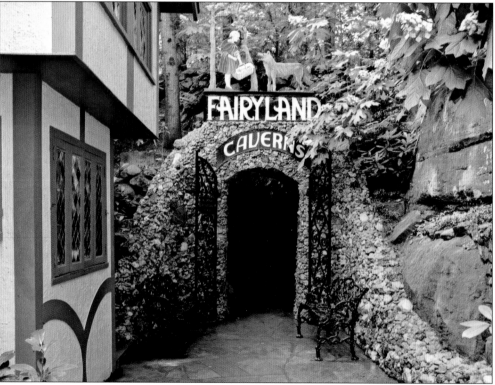

For a period around 2013, the former souvenir chalet was converted into Rocky's Haus, a meet-and-greet where the Rock City mascot hung out for Santa Claus–style encounters with guests. His living room—the intended railroad tunnel—was decorated with historic photographs and other Rock City memorabilia.

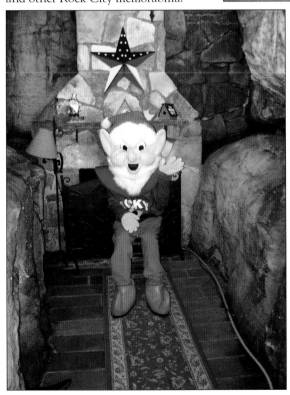

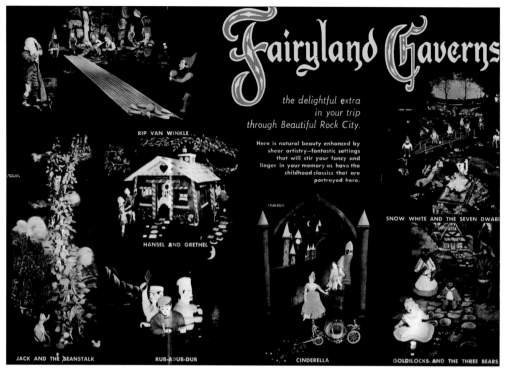

Construction of Fairyland Caverns stretched from 1947 into 1949. This incredible spread from a brochure of that period explains the new addition and gives a glimpse at some of its fanciful scenes. Rock City's use of ultraviolet black light to illuminate the tableaux was innovative, yet no one seems to be quite sure just how Garnet Carter arrived at the idea of utilizing it.

Some of the early Fairyland Caverns scenes did not last long. This "end of the rainbow" setting was one of the casualties—although interestingly, the rainbow motif did reemerge during Rock City's advertising campaigns of the 1970s.

In the first couple of rooms visitors entered in Fairyland Caverns, there were dozens of the imported German gnomes that were formerly stationed along the Enchanted Trail. Their retirement "indoors" ensured they would survive to delight visitors for decades to come.

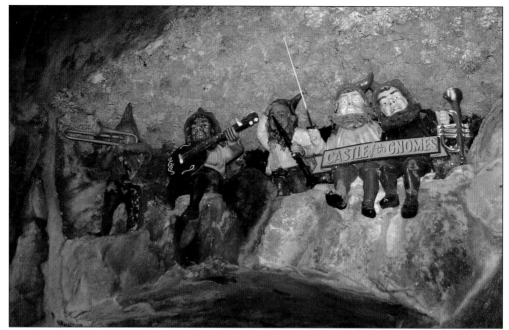

Remember the gnome orchestra that is seen rehearsing under Shelter Rock on page 25? Well, here they are again, perched on a ledge in the Castle of the Gnomes and seemingly just as musical as ever.

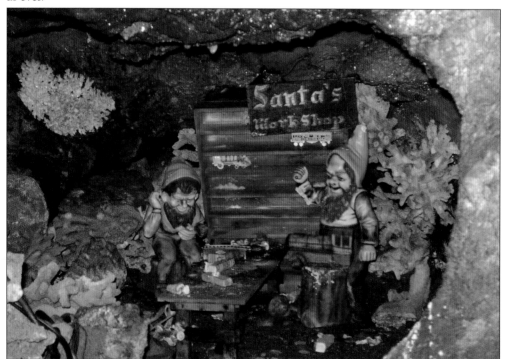

Apparently at some point, jolly old St. Nicholas set up a southern branch of his North Pole workshop deep in Fairyland Caverns. This scene was the work of one of the fairy tale display's caretakers during the 1970s and 1980s, Kenney Saylor.

These two Saylor sailors appear to be getting a bit seasick during their subterranean fishing trip. Small displays such as these were added to give people something to see before they reached the original beginning of the parade of Fairyland Caverns scenes.

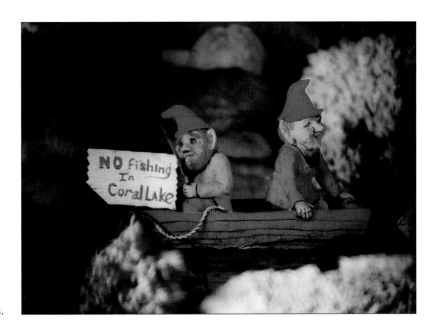

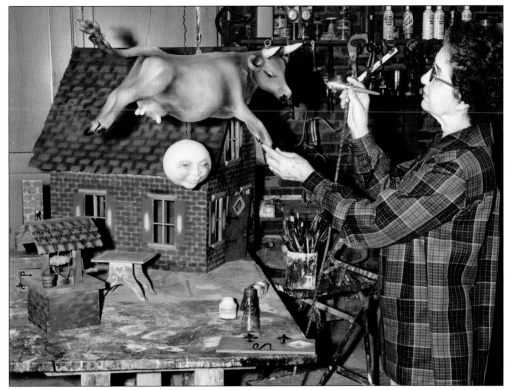

The acknowledged true creator of Fairyland Caverns was Jessie Sanders, a talented sculptor from Atlanta. She and her husband moved their workshop to Rock City in 1947 to oversee the creation of the new experience, and Jessie remained on duty for the next 21 years. (Rock City Archive.)

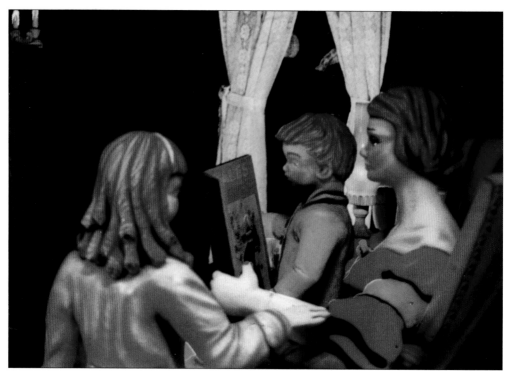

Just as with the concept of using black light, it was Garnet Carter's idea that the first scene in Fairyland Caverns be a mother reading bedtime stories, with the next scene showing the youngsters asleep as their "dream fairies" floated through the window. Both scenes are filled with tiny details that give them incredible realism.

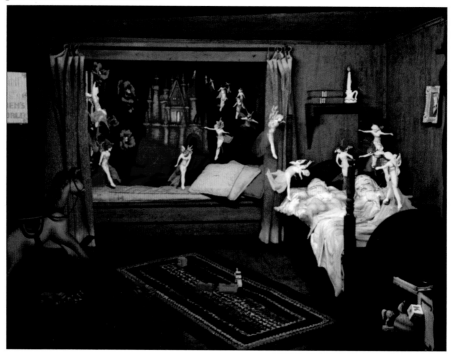

Overhead, the tutu-clad sprites continued their ballet. In Jessie Sanders's later years, when she resided in a nursing home north of Chattanooga, she fashioned dozens of similar fairies to hang from the ceiling of her room as a reminder of her most famous job.

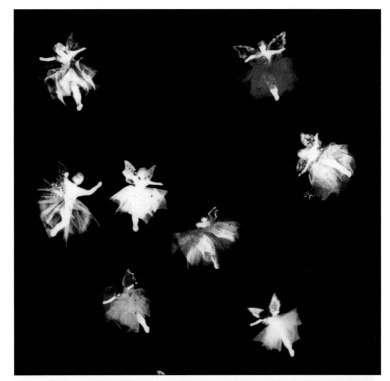

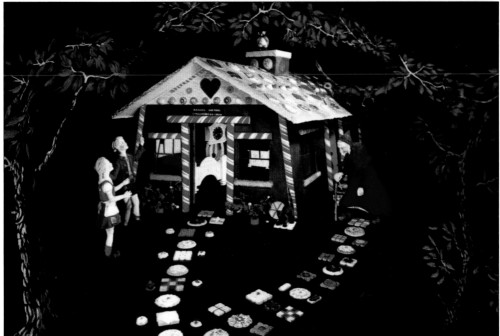

Fairyland Caverns was inspired by Frieda Carter's love for the classic European fairy tales. Perhaps for this reason, Rock City has consistently used the spelling "Hansel and Grethel" rather than the more familiar "Gretel." Under either name, the wicked witch's candy house is an impressively elaborate sight to see under black light.

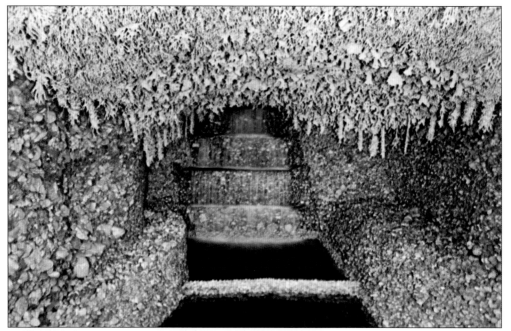

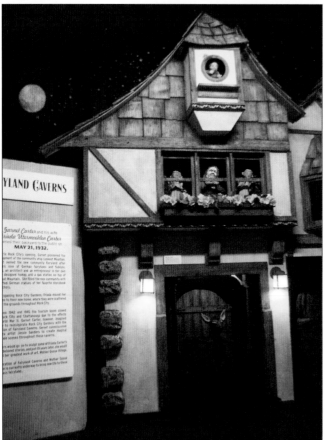

Crystal Falls was housed in a grotto where the walls and ceiling were thickly encrusted with chunks of quartz and sprays of coral. After nearly 70 years, this weighty ceiling began to give way, and the scene had to be dismantled.

Replacing Crystal Falls was this display, posthumously paying tribute to Jessie Sanders and her artistry. Included are her first sculpted figure, a baby deer from the Snow White scene, and a representation of the Pied Piper that she apparently created for a scene that was planned but never completed.

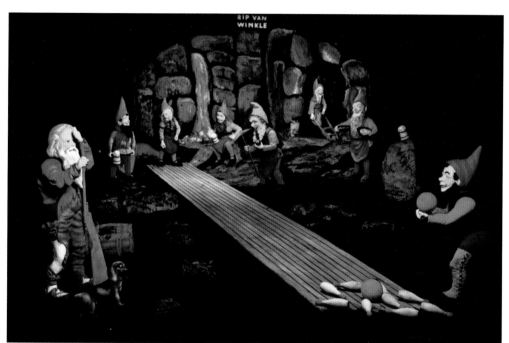

The figure of Rip Van Winkle, dazedly emerging from his long nap, was another of the imported statues that were originally installed in the Fairyland neighborhood, then spent a decade more as decorations along the Rock City trail. The bowling gnomes fit right in with the rest of their kin who hung out throughout the attraction.

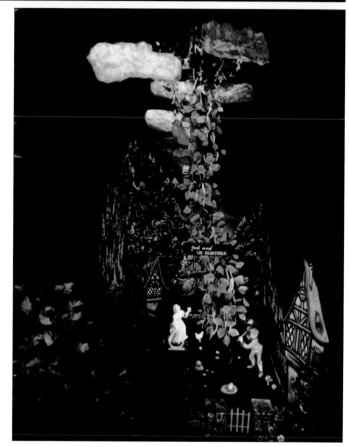

Jessie Sanders recalled that one of her most difficult jobs was finding a way to physically hoist the fee-fi-fo-fumming giant to the top of his beanstalk. Naturally, the figure had to be truly massive and heavy to appear in the correct scale with tiny Jack far below.

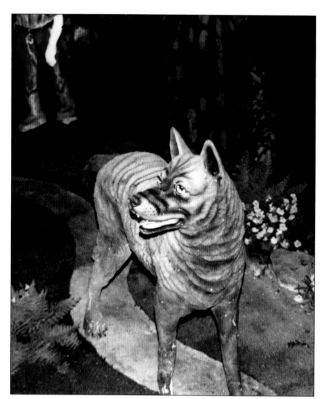

While Red Riding Hood made the transition from neighborhood to Enchanted Trail (as seen on page 20) to her own Fairyland Caverns scene smoothly, the Big Bad Wolf has been through some changes. For most of the time, he has been represented by the four-legged figure (left) of the 1930s, but for at least a brief period of time, he was portrayed as a more humanized character (below) standing on his hind legs.

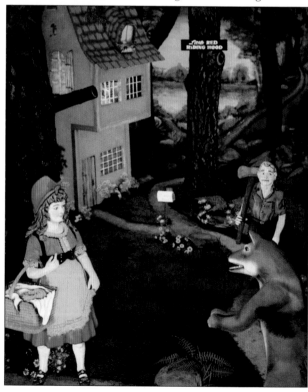

No collection of fairy tale scenes would be complete without Goldilocks and the Three Bears. Showing that the depiction remains a product of its time, there is little doubt that Papa Bear's pipe would not be considered acceptable if created today.

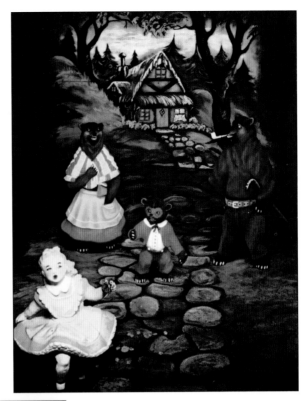

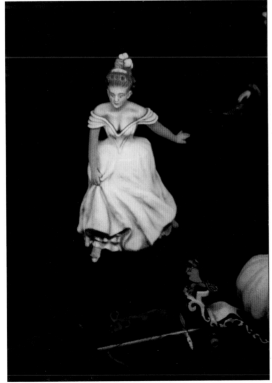

Jessie Sanders did not use drawings or diagrams to plan her figures ahead of time, preferring to work from her imagination. For Cinderella, however, Sanders did pose in front of a mirror to get the position of the running girl's hands the way she envisioned them.

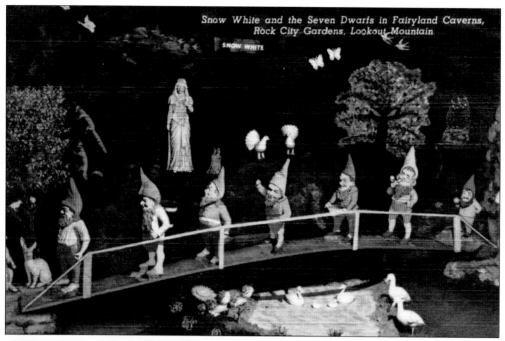

Snow White and the Seven Dwarfs in Fairyland Caverns, Rock City Gardens, Lookout Mountain

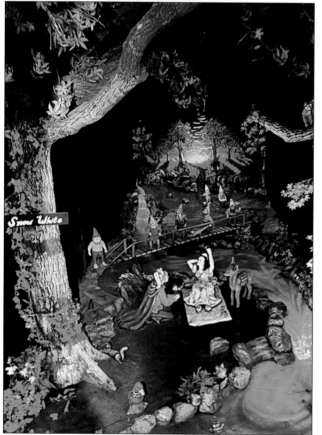

The original Snow White scene in Fairyland Caverns had been added to the Enchanted Trail in April 1938, during the initial popularity of Walt Disney's animated feature. Like most of the others, it was moved indoors during the caverns' construction 10 years later, and Snow White herself took a decided back seat to her seven vertically challenged companions.

As the other Fairyland Caverns scenes took shape, Garnet Carter felt the standing Snow White from 1938 looked a bit stiff. He then had Jessie Sanders sculpt what she referred to as a "reclining" Snow White, with the prince awakening her with a kiss—a scene that came from the Disney movie rather than the original folktale.

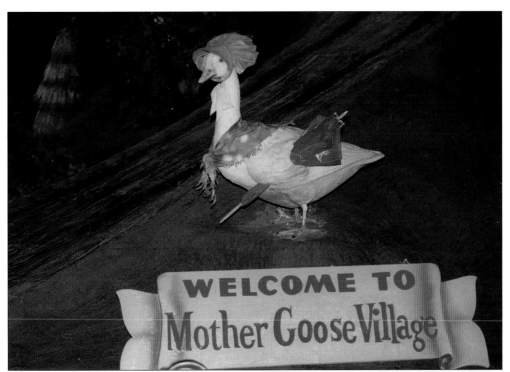

Mother Goose Village opened in 1964 as an addition to Fairyland Caverns. In a large auditorium-like room, characters from all the famous nursery rhymes cavorted under black light in a landscape of hills, valleys, and rivers. Jessie Sanders claimed that the whole display originated in a dream she had, in which she could see the whole thing remarkably clearly.

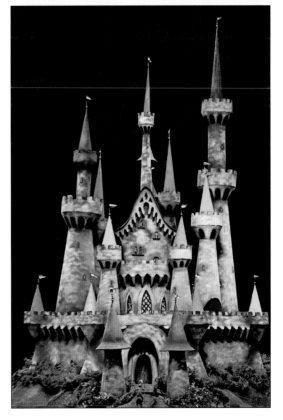

At the top of the Mother Goose Village hill stood Old King Cole's castle. At approximately 10 feet tall, its glowing ultraviolet-colored turrets have made for a memorable sight for more than 50 years.

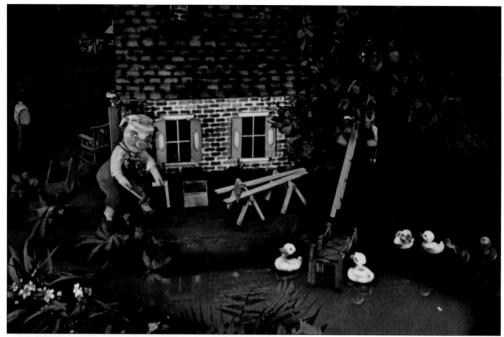

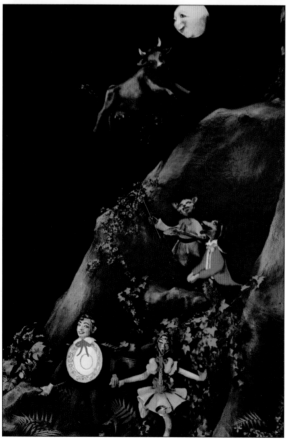

The story of the Three Little Pigs was not a nursery rhyme, but since Jessie Sanders had never gotten around to including it among the other Fairyland Caverns scenes, she belatedly incorporated it into her Mother Goose landscape. The yellow ducks in this photograph resemble the ones people used to pluck from the water to win a cheap prize at traveling carnivals.

Roadside attractions historian Doug Kirby once wrote, "Who needs drugs? Life doesn't get any freakier than Mother Goose Village." Looking at settings such as this one, it is obvious Kirby was not just whistling "Three Blind Mice."

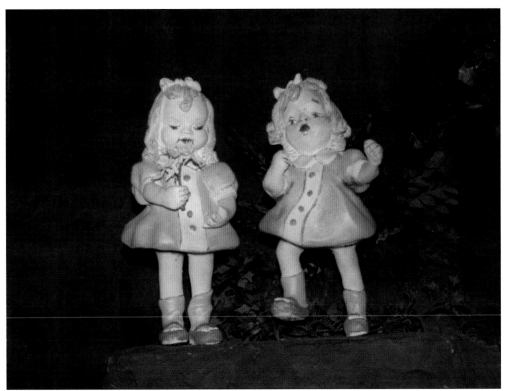

In 1968, Jessie Sanders decided to retire after more than 20 years of working on Fairyland Caverns. Her final two scenes were the Little Girl Who Had a Little Curl (above) and the Three Little Kittens (below). After her retirement, various successors filled in for her, occasionally—as has already been seen—adding new figures in their own artistic styles.

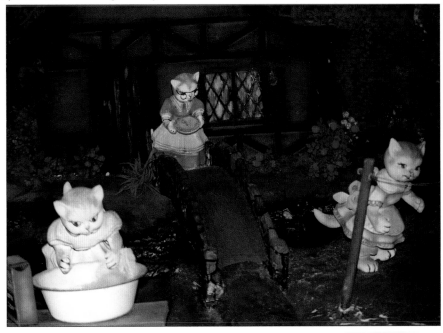

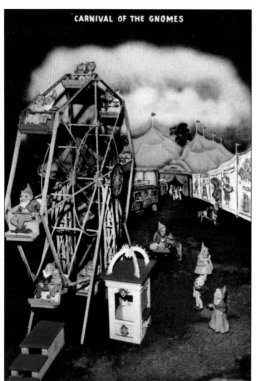

CARNIVAL OF THE GNOMES

Near the end of Fairyland Caverns was one of the few scenes not inspired by a classic folktale. As this early postcard indicates, the Carnival of the Gnomes originally featured a Ferris wheel that was rather stark in its unadorned metal girders.

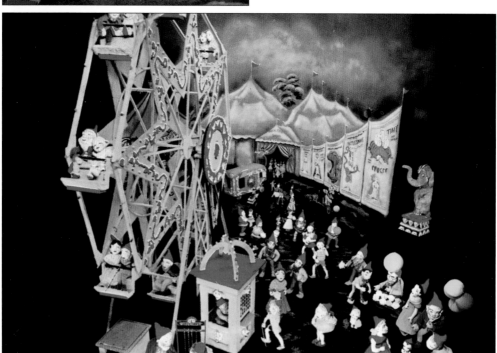

As seen for most of its history, today's Carnival of the Gnomes is much more colorful, with the Ferris wheel decorated in the most shocking shade of lime green possible. It is also one of the few scenes to feature animation, as the wheel turns furiously all day long.

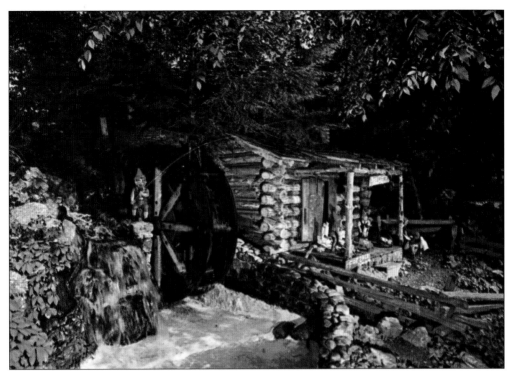

Upon emerging from the Fairyland Caverns tunnel into the daylight once more, tourists could be forgiven if they blinked a bit when confronted with the gristmill, operated by yet another crew of the industrious gnomes. Perhaps they were a bit too industrious because in 1999 the mill burned to the ground. Today, only its churning waterwheel remains to mark its former site.

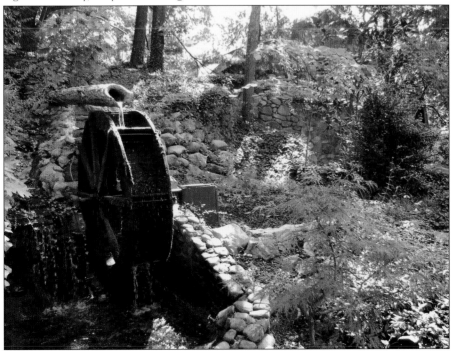

As a young girl of seven, Martha Bell Miller accompanied her mother and grandmother to Rock City's opening day on May 21, 1932. After retiring from careers as a schoolteacher and travel agent, in 1985 she became the living personification of Mother Goose at Rock City, greeting children with her Gussie Goose puppet and giving out "goosey hugs" for the next 20 years. Miller passed away at age 91 in September 2016.

*Five*

# A ROCK CITY
# FOR ALL SEASONS

Up until the 1980s, Rock City was typical of most southern tourist attractions in that it did most of its business for the year during the three summer months. That has now changed, thanks to a year-round program of special events. The Southern Blooms Festival each May neatly coincides with the annual celebration of the gardens' 1932 opening. (Rock City Archive.)

An early attempt at a special event was this late-1970s stage show. The famous Hanna-Barbera cartoon characters (including Huckleberry Hound, Yogi Bear, and Scooby-Doo) came down from their usual home at Cincinnati's Kings Island theme park to entertain Rock City guests. (Rock City Archive.)

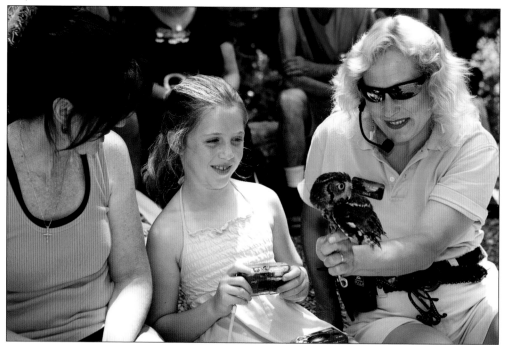

The Rock City Raptors show gets visitors up close and personal with a variety of birds of prey, including owls, eagles, and others. It could be said that the performers literally watch their audience like a hawk. (Rock City Archive.)

Rock City's annual Christmas celebration began modestly in the early 1970s, with a few decorations placed along the Enchanted Trail. This lovely nativity scene was one of the earliest installations, nestled in a rocky grotto in the Grand Corridor.

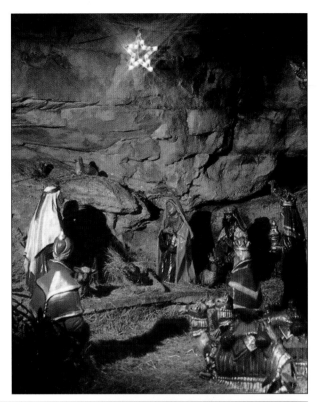

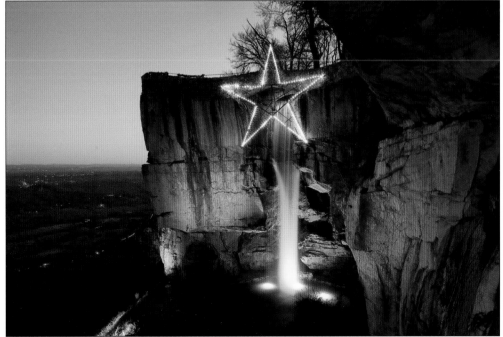

Also dating to the 1970s was the tradition of a giant lighted star suspended from Lover's Leap. It has been enlarged and updated a few times, but today's version of the star is truly a spectacular sight, whether viewed up close or from the valley below. (Rock City Archive.)

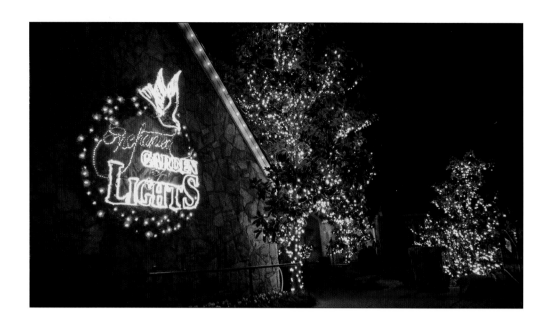

In 1995, Rock City debuted the Enchanted Garden of Lights, which took the earlier Christmas displays as a start and expanded into a comprehensive decorating program for the entire park. From the entrance court (above) through the Grand Corridor (below) and beyond, nighttime visitors are confronted with one spectacular display after another, all combining to put visitors in a joyous yuletide mood. (Both, Rock City Archive.)

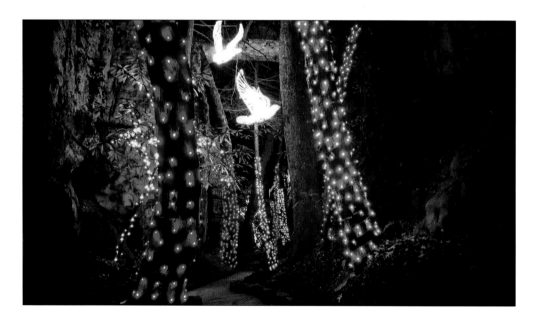

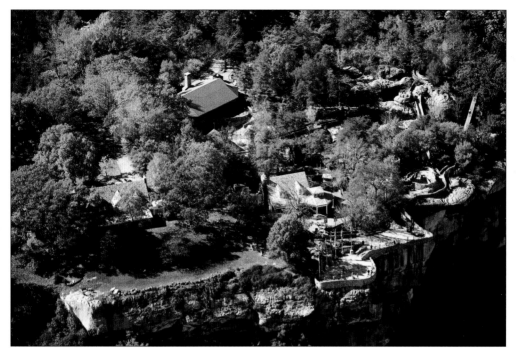

The fall foliage around Lookout Mountain is always breathtaking. So it should not have been surprising that Rock City decided to promote autumn as its second-busiest time of the year for special events. Compare this aerial view with the one on page 36 to see just how many additions have been made in the intervening years. (Rock City Archive.)

While there is plenty of autumn excitement going on at Rock City's main property, even more events take place down in the valley at Blowing Springs Farm. For example, scary Halloween celebrations are confined to that venue, since no one wants kids who visit Rock City to be frightened away. Fall displays there remain calmingly benign, such as this one.

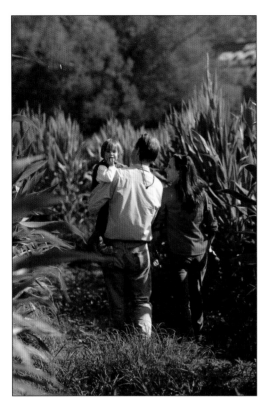

Alongside the Halloween creepiness at Blowing Springs Farm, there is Rock City's Enchanted Maize—some worthy wordplay to be sure. Each year, a cornfield is planted with the rows in different configurations and visitors have to find their way out. (Rock City Archive.)

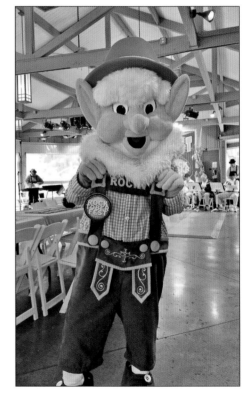

Meanwhile, back atop the mountain at Rock City, weekends in October bring Rocktoberfest, for which Rocky the Elf trades in his usual red-and-green ensemble for a Bavarian outfit. (Rock City Archive.)

72

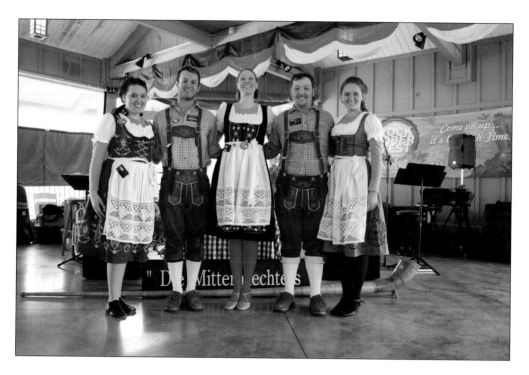

The idea behind Rocktoberfest stems from Frieda Carter's own German family heritage. The oom-pah-pah music and imported beer are enough to make anyone looney for lederhosen. An honored guest during each Rocktoberfest is Ik, the King of the Trolls. He should probably be thought of as the royal leader of Rocky's German side of the family. (Both, Rock City Archive.)

A special event that began more recently is Fairytale Nights, which take place each spring, usually in April. The beloved characters who hang out in Fairyland Caverns (and even some who never made it into Jessie Sanders's displays) seemingly come to life and take over the rest of the Enchanted Trail to create an after-dark world of wonder. (Both, Rock City Archive.)

*Six*

# TO MISS ROCK CITY WOULD BE A PITY

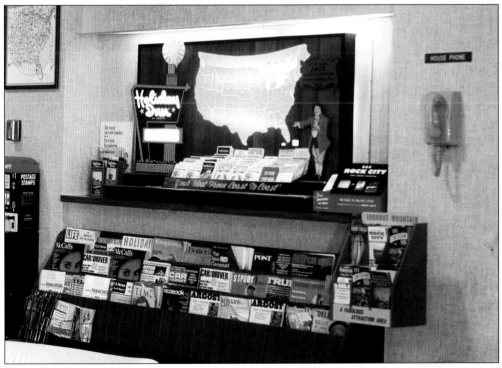

In the final chapter, readers are reminded of just why Rock City developed a reputation as one of the most aggressive advertisers of all the South's many roadside attractions. This display in the lobby of a late-1960s Holiday Inn provides plenty of details to examine, from the mileage meter on the counter to the rack of brochures for all the Lookout Mountain attractions.

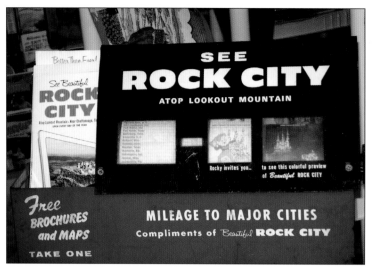

The Rock City mileage meters came in both a counter version (as seen on the previous page) and a freestanding model. Both could be found in motel lobbies, restaurants, and service stations throughout the Southeast—and each one was customized to give the distance to more than 100 different cities from the specific location where it was to be placed.

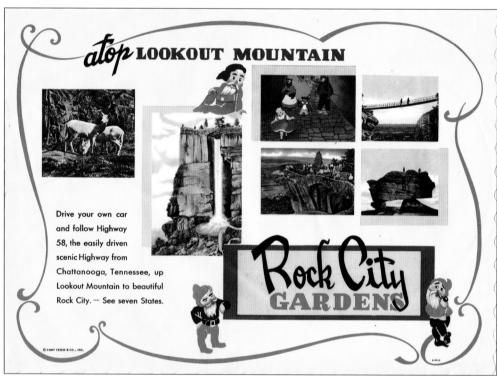

Rock City had a most beneficial relationship with the many mom-and-pop restaurants that lined the highways in the pre–fast food days. Place mats, such as this 1950s example, were distributed in many different states, spreading the word about Rock City to a somewhat captive audience of hungry tourists.

Brochures were always a major form of Rock City advertising. These two, from the early years, definitely betray their ages as relics of a bygone era—especially the one on the left, showing the "unimproved" Lover's Leap of the mid-1930s—but their messages remain basically the same today.

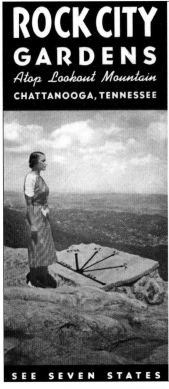

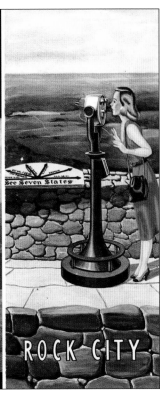

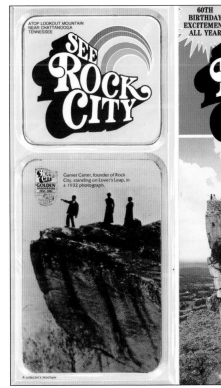

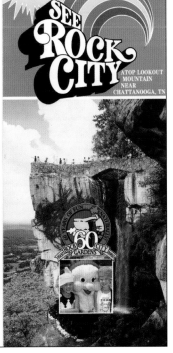

By the time of Rock City's 50th anniversary in 1982 (left), a colorful rainbow had been added to the advertising to break up the monotony of the traditional white-on-black motif. By the 60th anniversary (right), those monochromatic colors had been replaced by sky blue.

In time for the 70th and 80th anniversaries, old became new again. Rock City's advertising agency designed a revamped logo that reverted to white letters on a black background, while still bringing it into the modern tourism era. Perhaps no other attraction is able to sell itself with such nostalgia.

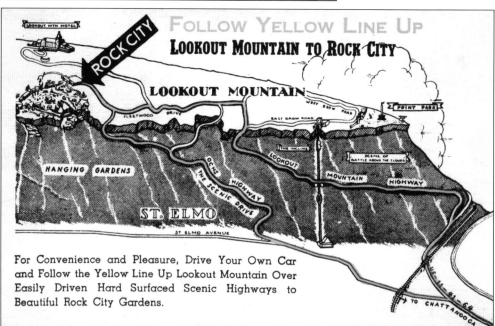

From the 1930s until the late 1940s, Rock City directed tourists its way by painting a yellow line on State Highway 58 leading from the foot of Lookout Mountain to the parking lot. Once highway striping became more standardized, the line was painted over, and "Follow the Yellow Line" became a forgotten Rock City advertising slogan.

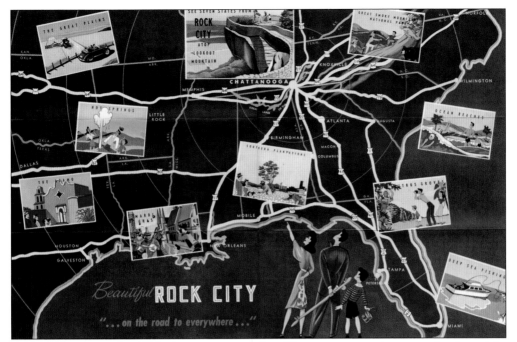

Because so many major US highways intersected in Chattanooga, northern travelers bound for sunny Florida or those traveling home in the other direction could hardly avoid passing Rock City. Thanks to a seemingly endless parade of advertising, there were few tourists who had the willpower to not stop.

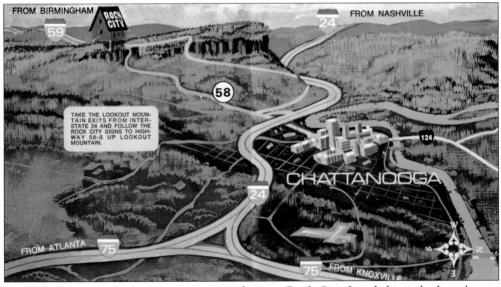

Once the interstate highway system got under way, Rock City found that it had to alter its advertising campaign. Now, tourists had to be convinced to actually exit from the freeway and make the drive up the mountain to see Rocky and his fairyland friends.

Although Rock City's billboards had traditionally been white letters on a black background, by 1985 the feeling was that they would more accurately portray the park if they gave the impression of clear blue skies. Painters Tommy and Lynn Moses set out on an odyssey to recolor the background of every billboard a bright blue.

Rocky the Elf was never far away when it came to Rock City's advertising. For many years, this billboard near the state line greeted those who were entering Chattanooga on I-24.

By the end of the 1990s, new computer technology enabled Rock City's billboards to be printed photographically and show actual scenes from the park, rather than depending upon the sign painters' art. The addition of the website address was yet another example of bringing a Depression-era attraction into the new world of cyberspace.

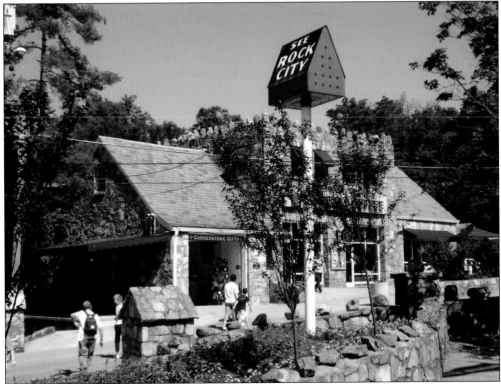

The famed Rock City birdhouse became one of the most familiar advertising symbols of the attraction. A small version was produced as a gift shop item—and is still a best seller after more than 60 years—but larger commercial examples such as this one were placed on motel lawns, in front of gas stations and restaurants, and anywhere else they could squeeze into.

This 1960s Christmas card sent out by Rock City to its associates shows just how much the birdhouses had come to be associated with its advertising. (Rock City Archive.)

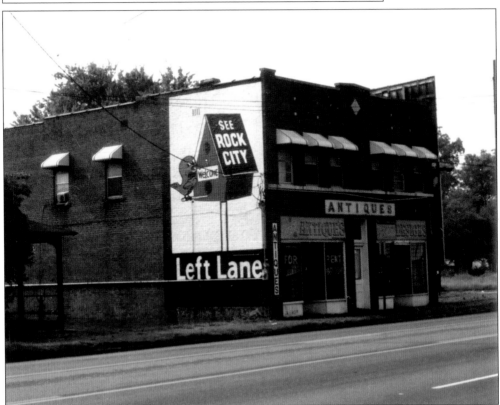

This painted brick wall sign of a birdhouse could still be found on Chattanooga's Broad Street in the early 1990s. A few years earlier, a giant billboard version of the symbol stood a few blocks south of this building and was widely advertised as the "world's largest birdhouse."

The vast majority of the old-style Rock City birdhouses flew the coop after new highway beautification laws and more regulations on signage were enacted. In 2013, this crumbling example could be found on US 11 near Trenton, Georgia, but it has since disappeared.

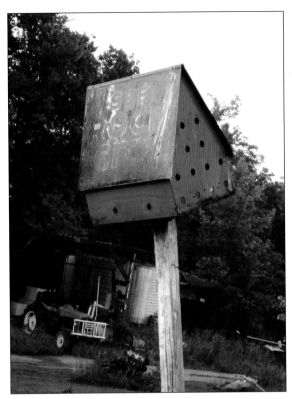

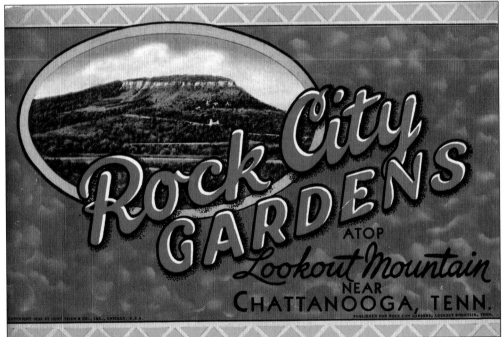

Back atop Lookout Mountain, one of the best ways to preserve one's visit to Rock City was with a souvenir booklet that collected together many of the most attractive postcards. This booklet was first published in 1938 and remained on sale—with only minimal updating—for a decade.

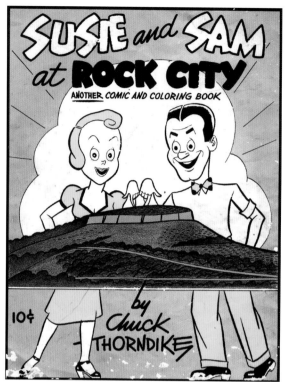

This most unusual souvenir item was offered in the early 1950s. It is a combination coloring book and comic book, depicting the experiences of newlywed couple Susie and Sam as they tour Rock City. Along the way, the romantic pair makes one wisecrack after another, almost as if the script had been penned by a team of Bob Hope's writers.

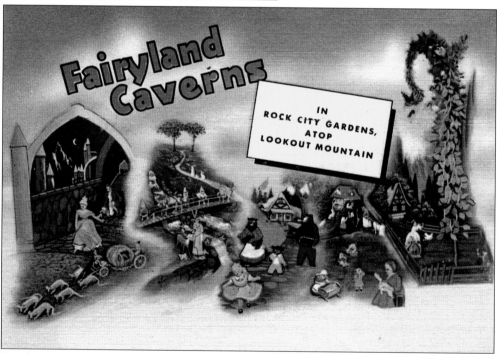

Fairyland Caverns got its own linen-finish postcard folder soon after its addition to Rock City. The scenes and their fluorescent colors have always been difficult to reproduce photographically, but the rather primitive printing techniques of the 1950s made them look especially odd.

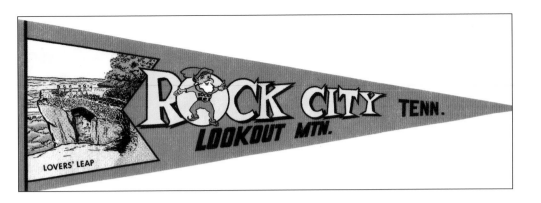

Souvenir felt pennants were a staple of any tourist attraction's gift shop. Rock City sold many, many different styles over the years. The above example was probably originally designed in the 1960s, since the now obscure Camera Obscura building is included. The one below is highly unusual in that it concentrates totally on scenes from Fairyland Caverns, along with a font Rock City did not use for any of its other publicity.

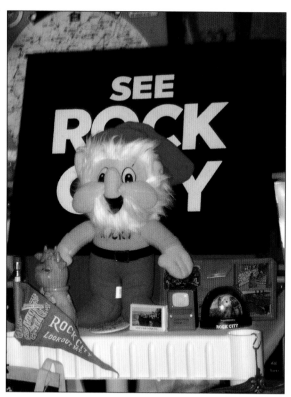

Besides pennants, Rock City's souvenirs took on hundreds of different forms. Here are just a few of them, from a stuffed Rocky to a snow globe to a giant pencil topped with a miniature felt pennant to one of the bars of soap the attraction distributed to motel rooms throughout the South.

Even a casual glance at Rock City's present-day gift shop will show that its souvenirs have not diminished in quantity or quality. All the old favorites still exist in one form or another, plus many new ones.

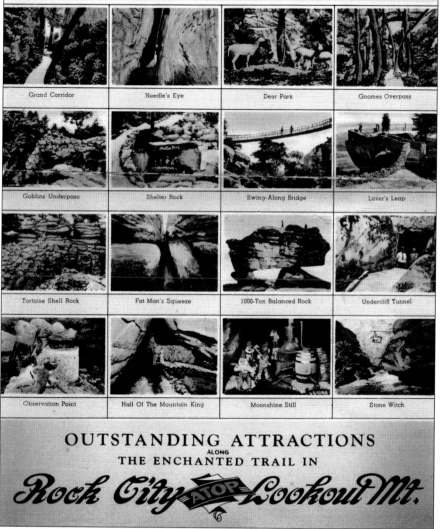

# CAUTION -- PLEASE READ AND OBSERVE

All are warned to stay in the Trail and away from places where a fall might result from a slip of the foot or a mis-step. Please do not deface the rocks in any way—do not pull the shrubbery or flowers or limbs off the trees. Remember that you trespass if you violate this caution, or if you disturb anything within these grounds. **DO NOT LEAVE THE TRAIL.**

DO NOT TOUCH OR DISTURB THE FORMATIONS OR ANYTHING IN FAIRYLAND CAVERNS.

| | | | |
|---|---|---|---|
| Grand Corridor | Needle's Eye | Deer Park | Gnomes Overpass |
| Goblins Underpass | Shelter Rock | Swing-Along Bridge | Lover's Leap |
| Tortoise Shell Rock | Fat Man's Squeeze | 1000-Ton Balanced Rock | Undercliff Tunnel |
| Observation Point | Hall Of The Mountain King | Moonshine Still | Stone Witch |

# OUTSTANDING ATTRACTIONS
### ALONG
## THE ENCHANTED TRAIL IN

*Rock City* ATOP *Lookout Mt.*

Some of the most commonly found vintage Rock City souvenirs are the "giant postcards" that were handed out at the beginning of the Enchanted Trail. Updated every few years, they gave a preview of the sights to be seen. This early example was obviously produced before the addition of Fairyland Caverns, as it ends with the Stone Witch; the line of type acknowledging the new fairy tale display was stuck on as an afterthought until a new guide card could be designed.

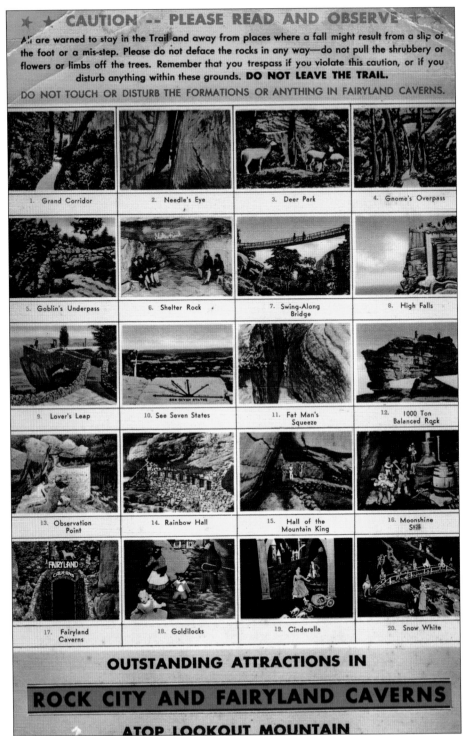

1. Grand Corridor
2. Needle's Eye
3. Deer Park
4. Gnome's Overpass
5. Goblin's Underpass
6. Shelter Rock
7. Swing-Along Bridge
8. High Falls
9. Lover's Leap
10. See Seven States
11. Fat Man's Squeeze
12. 1000 Ton Balanced Rock
13. Observation Point
14. Rainbow Hall
15. Hall of the Mountain King
16. Moonshine Still
17. Fairyland Caverns
18. Goldilocks
19. Cinderella
20. Snow White

## OUTSTANDING ATTRACTIONS IN

# ROCK CITY AND FAIRYLAND CAVERNS

## ATOP LOOKOUT MOUNTAIN

This slightly later guide card bumps the number of highlighted sights from 16 to 20 and finally includes Fairyland Caverns as the last four. In the final panel, note the original 1938 Snow White statue along with Jessie Sanders's baby deer that began her Rock City career.

This ultra-colorful Rock City guide from the early 1960s is almost bright enough to make one's eyeballs melt. It also includes the most commonly seen pose of Rocky the Elf during that period. (Rock City Archive.)

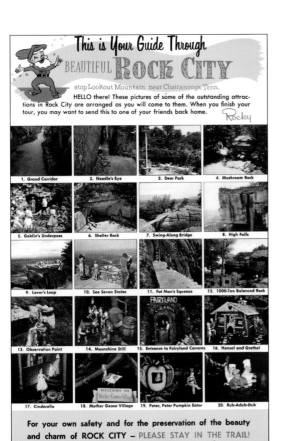

The 1960s guide card remained basically unchanged into the mid-1980s. Once Mother Goose Village was added to the mix, there was very little different to include until the big push to expand and enhance Rock City's lineup of attractions during the 1990s.

Earlier, it is shown how Rock City used restaurants as an advertising outlet in the 1950s. By the 1960s, one of the most successful of those promotions was its custom of printing advertisements on the backs of guest checks, which were distributed by the millions. This example makes sure to point out the "new interstate highways" that were rapidly changing the face of tourism. (Rock City Archive.)

Now, it is time to look at those famous Rock City barns that were its most familiar advertising icons. Beginning in 1935, the painted roofs could be found as far north as Lansing, Michigan, and as far west as Marshall, Texas. Travelers approaching Chattanooga read about Rock City for hundreds of miles (or even a day or two) before they got there.

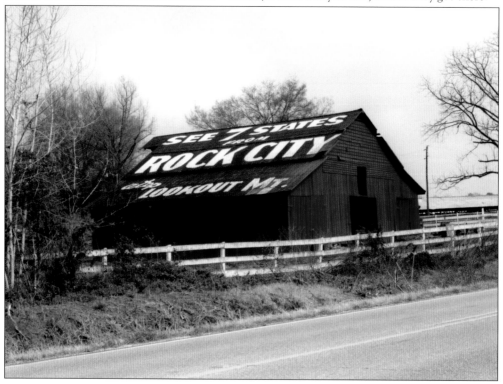

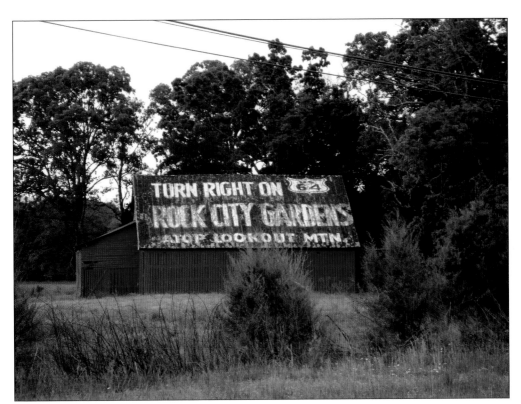

Barns such as this one, on US 411 near Madisonville, Tennessee, show how drivers navigated before the days of Google maps and GPS. The indicated right turn onto US 64 would have occurred several miles south in Cleveland.

Meanwhile, on US 64 west of Chattanooga, at Frankewing, this beautiful signage assured folks that they were on the right track. The difficulty of driving and trying to read a road map at the same time made such directions quite helpful.

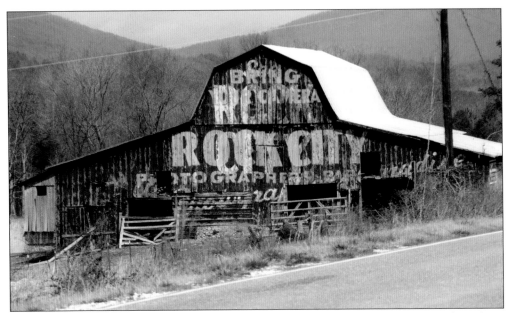

Some barns remained in Rock City's employ for so long that their messages changed. Looking closely at this example, which once stood alongside US 11 in Alabama, a person might be able to make out at least a couple of different configurations of its "Photographer's Paradise" slogan.

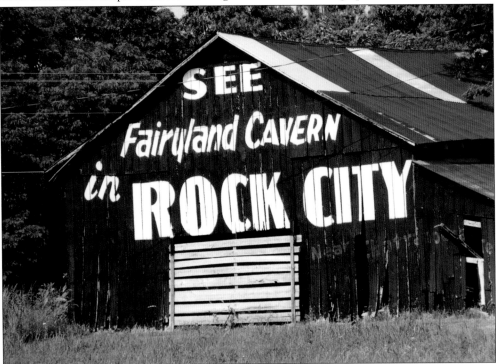

For some reason, it was rare for Fairyland Caverns to be included as part of the barn advertising campaign. This one on US 72 near Rogersville, Alabama, was one of the few. Even then, the wording is slightly incorrect, but earlier photographs show an even less accurate "See Fairyland Cave in Rock City."

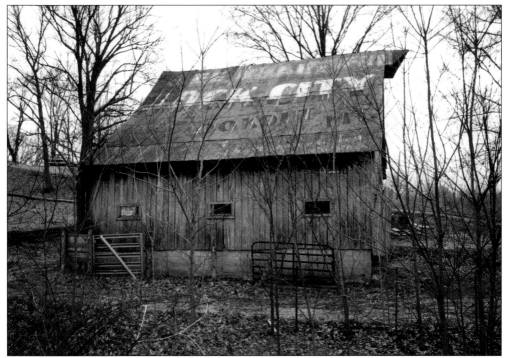

As mentioned earlier, Rock City's barns could be found far afield, as long as the drivers who passed them might reasonably be expected to be headed toward Chattanooga. This almost decayed barn appears to be gasping its last breath on US 51 near Vienna, Illinois, in the early 1990s.

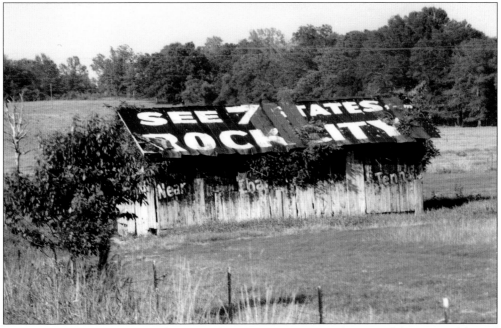

Another deteriorating far-flung barn was this one on US 31 near Clanton, Alabama. Northbound tourists would have had to make a significant detour in order to visit Chattanooga, but it was not completely out of the question.

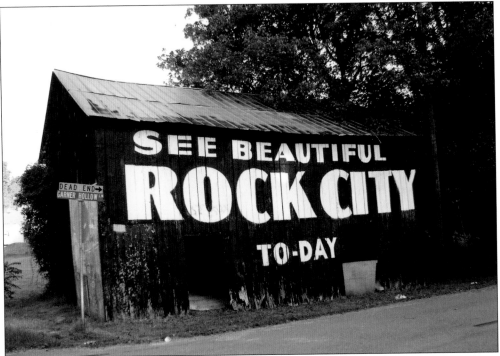

In contrast to the fading barn signs, this one on US 441 near Sevierville, Tennessee, remains well-maintained today. Of added interest is that the left end of the barn is patched with the remnants of a painted Howard Johnson's billboard advertising one of that once powerful chain's locations in Knoxville.

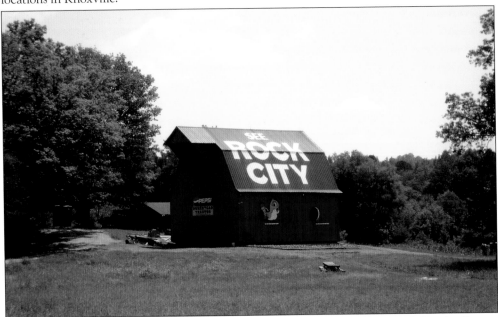

This barn, combining two advertising icons by being painted to resemble a Rock City birdhouse, originally stood near Dalton, Georgia, on I-75. In 2002, it was moved and reassembled on Rock City's Blowing Springs Farm property, ensuring its preservation to delight present and future tourists.

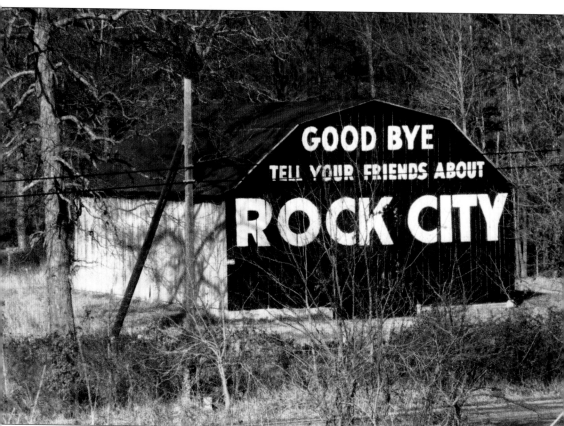

What better way to end this journey than with this unique barn alongside I-24? It was perhaps the only one in Rock City's long list to face drivers who were heading away from Chattanooga and toward Nashville. As the journey through this book is concluded, perhaps it would be wise to heed its advice; there truly is no better way to appreciate this long-standing roadside attraction than to SEE ROCK CITY. (Rock City Archive.)

# Discover Thousands of Local History Books Featuring Millions of Vintage Images

Arcadia Publishing, the leading local history publisher in the United States, is committed to making history accessible and meaningful through publishing books that celebrate and preserve the heritage of America's people and places.

## Find more books like this at
## www.arcadiapublishing.com

Search for your hometown history, your old stomping grounds, and even your favorite sports team.